THE
RICHMOND

ON THE COVER: The monument to Thomas Jonathan Jackson, better known as Stonewall Jackson, stands in Richmond's Capitol Square. The bronze statue faces Thomas Jefferson's classical Virginia State Capitol and has his back to city hall and Ford's Hotel. Currently the Capitol building is undergoing renovations for the 2007 Jamestown anniversary. The city hall building still stands but no longer functions as a state building. A new city hall building stands on the other side of Broad Street. Ford's Hotel was demolished, and now the Supreme Court of Appeals Building stands in its place. Thus is the state of Richmond's building use today; in an effort to restore the old, renovate the past for the present, and construct for the future, the city continues to prosper.

THEN & NOW
RICHMOND

Keshia A. Case

ARCADIA

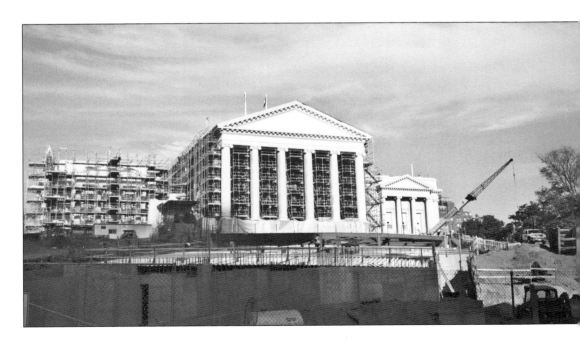

Presently the Virginia State Capitol is undergoing an expansion and renovation project. The building project should be complete for America's 400th anniversary celebration in Jamestown in 2007.

CONTENTS

Acknowledgments

I would like to thank the following individuals for their assistance with the research of this book: Ray Bonis, Special Collections and Archives, James Branch Cabell Library, Virginia Commonwealth University (VCU) Kathryn Campbell, Department of Art History, VCU; Susan Williams, Medical College of Virginia Campus VCU; Mari Julienne, the Library of Virginia; Melinda Skinner, Alliance to Conserve Old Richmond Neighborhoods; Susan Pollard and Adam Jackson, Department of General Services, Commonwealth of Virginia; Karen Getty and Suzanne Freeman, Virginia Museum of Fine Arts; and Meghan Glass, Valentine Richmond History Center.

My sincerest thanks to my husband, John, and son, Alex, who endured the many visits to the many sites pictured in this book.

This book is dedicated to my mother, whose love and support make my accomplishments possible.

INTRODUCTION

Richmond, the capital of the Commonwealth of Virginia, has a rich history that dates back to the early 17th century when Thomas Stegg Jr. acquired 1,800 acres on the southside of the James River. Stegg died childless and therefore left his land to his nephew William Byrd in 1671. William Byrd's first son, William II, was born in Virginia in 1674. The younger Byrd noted that the view from the hills overlooking the James River reminded him of the Thames River in Richmond, England. This comparison provided the city with its name.

William Byrd II built the plantation home of Westover between the falls of the James River and Jamestown. For many years, he resisted using his land to build a town. However, in 1733, Byrd along with Maj. John Mayo laid out the lots for Richmond and Petersburg. A plot was donated for the building of St. John's Church in 1741. The neighborhood surrounding the church was named Church Hill. Byrd's remaining plots were advertised in the *Virginia Gazette* for £7 each with the provision that a house be built on the property within three years. One of the first land owners was Jacob Ege, who purchased land on Main Street. In 1739, Ege built what is today known as the Old Stone House, home to the Edgar Allan Poe Museum.

Richmond played an important role in the nation's war for independence and in the Civil War, serving as the capital for the Confederate States of America. In 1862, the Seven Days' Battle was fought in the farm lands of Richmond on Malvern Hill. In 1864, Fort Harrison, located about 10 miles from the city of Richmond, was captured by Union troops. On April 2, 1865, Jefferson Davis received news that Lee could not hold the defense at Petersburg. Richmond was ordered to evacuate, and the city was set on fire. Most of Main Street was destroyed that night, and the war was lost by the South. In the 1870s to 1880s, Richmond would enter a period of reconstruction.

After Reconstruction, Richmond's location along the James River and its close proximity to the North helped spur an economic revival. The city became the center for the export of tobacco and cotton as well as a port for English ships looking to trade goods. The Seventeenth Street Market, Richmond's shopping center of the past, was created as a result of the growth of commerce, providing vendors with a space to sell food, textiles, and household goods. However, the introduction of rail travel ended the use of the river. Trains were faster, cheaper, and provided a method of transporting goods to growing middle America. Richmond continued to prosper because of the new clientele and greater economic distribution provided by the railway system. By the 1890s, Richmond's growing economy prompted the development of new neighborhoods and new buildings, epitomized by the grandeur of Monument Avenue, giving it a prominent place in what was then called the "New South."

From the 1870s to 1890s, Richmond was a city of growth. Neighborhoods, parks, and public buildings were being constructed to meet the needs of the city. The philanthropic efforts of Maj. Lewis Ginter had a great impact on Richmond at this time, and he personally funded the construction of several of the buildings mentioned in this book. The Richmond suburb to the north, Barton Heights, was made possible with the advent of the streetcar line. The use of the horse and carriage was on the verge of being obsolete with cars coming on the market in the 1900s. Early-19th-century buildings like Richmond's first City Hall and the first Henrico County Court House were demolished and rebuilt in a style and manner to fit the times. For recreational amusement, the public sought the parks of Reservoir, Forest Hill, and

Lakeside. The historic Monument Avenue began in the 1890s with the dedication of the Robert E. Lee monument. The tobacco fields of Monument Avenue would soon be replaced with impressive homes and churches. Hollywood Cemetery was established in the 1850s and later gained prestige with the burials of Pres. John Tyler, Pres. James Monroe, Pres. of the Confederacy Jefferson Davis, and many Civil War generals. Richmond developed into a city that was proud of its past but not afraid to make advances into the future.

This book compares 1890s historical images housed in Special Collections and Archives, James Branch Cabell Library, VCU Libraries, with contemporary views taken by the author. The interior photographs of the Capitol were provided by the Department of General Services, Photo Division. Together these images provide a sample of the historic structures of Richmond. Preparation for this book required the visitation and careful examination of hundreds of sites to find what remained of their past. Notably many of Richmond's historic buildings of the 1890s survive due to the efforts of organizations fighting against their destruction. These organizations include the Alliance to Conserve Old Richmond Neighborhoods, the Historic Richmond Foundation, and the Association for the Preservation of Virginia Antiquities. Unfortunately the fight for preservation is never ending, as one never knows which building may be erased from our scenery next.

This book provides a historic view into a period of great change in Richmond, between the end of the Civil War and the Victorian era. Richmond had recovered from the destruction brought by the war and growth was inevitable. In 1890, the population was approximately 81,000. There were 110 miles of streets, one-fifth of which were paved; seven parks covering 357 acres; and six colleges—Richmond College, Richmond's Female Institute, Medical College of Virginia, University College of Medicine, and two seminary schools, one for blacks and one for whites. There were approximately 100 churches, 8 hospitals and 2 daily papers. The mainstay of the city was the tobacco trade. Today the Richmond city population is approximately 1,023,000, and even though the mainstay is not tobacco, many of the remaining tobacco factories have a function and have been renovated into apartments. The city will continue to grow, and hopefully the community will always find a use for the buildings of the past so these structures will be here for our future.

As you read through this book, enjoy exploring the past, comparing it to the present, and take some time to wonder what the future might bring. For Richmond, a city that has always recovered from tragedy, the future looks promising.

Chapter 1

NEIGHBORHOODS, RESIDENCES, AND SOCIAL CLUBS

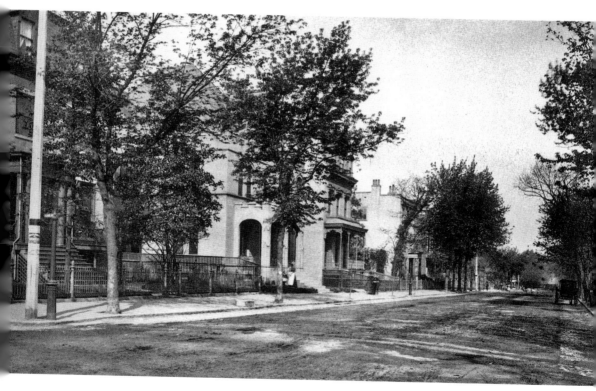

Grace Street, lined with townhomes, was a fashionable address in the 1890s. The homes were built by upper- and middle-class citizens. The street moved from the city west through the home of Col. John and Abigail Mayo, called Bellville. They allowed Grace Street to run through their property to reach Richmond College. This photograph was taken at the corner of Grace and Adams Streets. Many of the homes pictured have iron porches, a decorative trend in Richmond that can be found in Richmond's Church Hill and Jackson Ward neighborhoods.

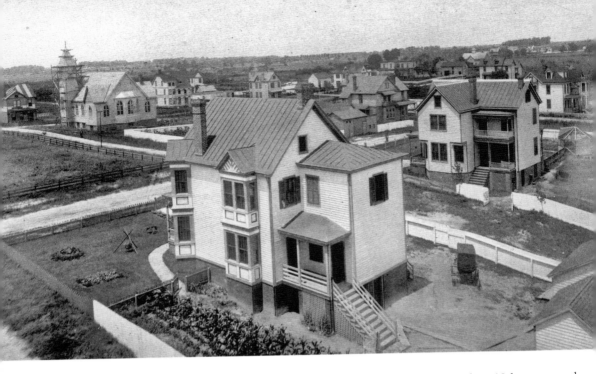

B arton Heights was one of Richmond's first subdivisions. Developed in the late 19th century, the neighborhood lies north of the city across the Samuel Tucker Bridge. A neighborhood directory stated the subdivision grew at a steady pace, a few houses the first year, and that homes were only built on demand. Two hundred dollars in cash for the down payment and $25 per month purchased a home in Barton Heights. The homes are a variety of Victorian styles, including Queen Anne and American bungalow. Both of the homes in this picture still stand today.

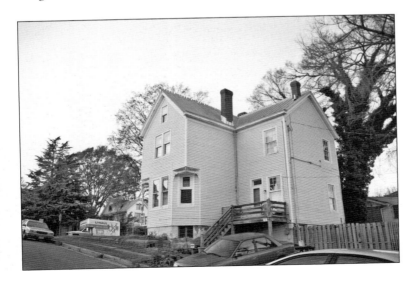

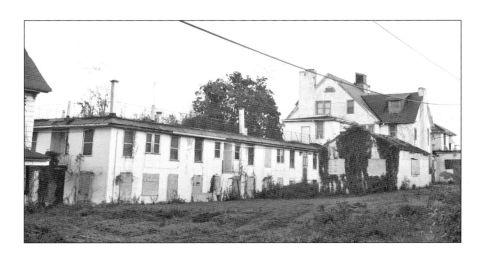

James Barton left Little Rock, Arkansas, for Richmond in the 1880s. Barton was the real estate developer of Barton Heights in the 1890s. His home still stands at 2112 Monteiro Avenue. Elevated on a ridge, the Barton residence was a grand example of late-19th-century suburban architecture. The Barton Heights neighborhood of today has seen better days. In recent years, the Barton residence has fallen into decay. A large extension was constructed on the back to make additional space for a nursing home. The building is no longer in use and is now boarded up. Coalitions have been organized to help improve the neighborhood of Barton Heights.

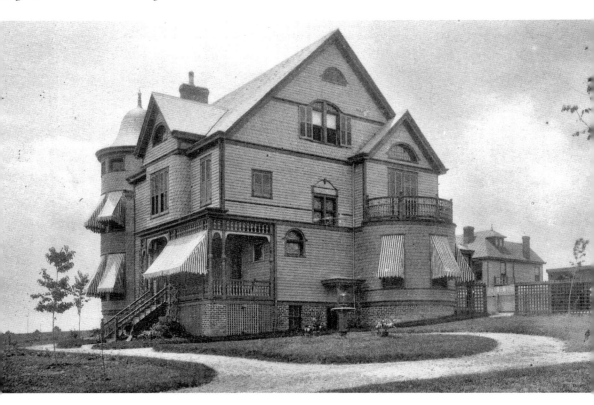

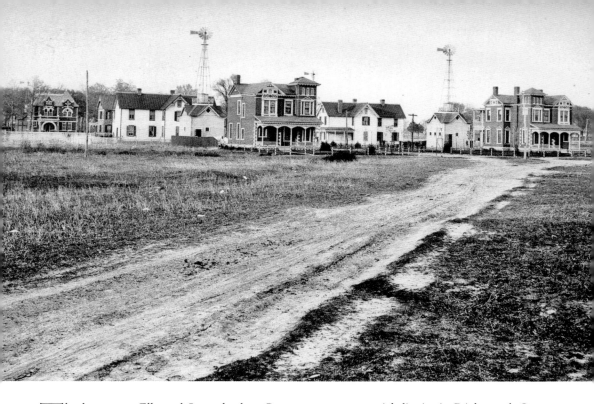

The homes on Ellwood Street lead to Carytown, a commercial district in Richmond. Carytown was established in the 1930s, after the neighborhood pictured here, with the Carytown Park and Shop. The homes shown here were built in the late 19th century. The two homes in the foreground of the historic photograph are still standing as well as the home with the large arch in the front. The neighborhood is now an extension of Richmond's historic Fan District. The Fan District gets it name from the shape the streets create. The area starts at Monroe Park and the streets are angled out to the west, giving the layout of a cone or fan shape.

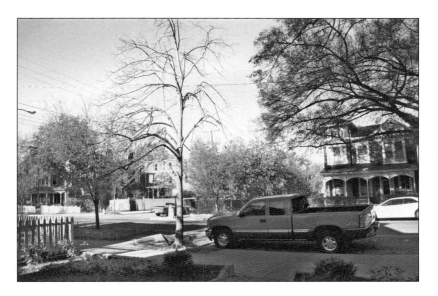

Leonard Heights was an 1890s neighborhood located off of Commonwealth Avenue, Maynard Street, Shenandoah Street, and Monument Avenue, west from the city of Richmond. The name Leonard Heights has long been forgotten. The 1890 photograph shows a few recently completed houses in the distance. Also in the vintage photograph is a street sign for Morris Avenue, which is now Sauer Avenue. One of the 19th-century homes still stands at Patterson and Sauer and is pictured in this recent photograph. The house is in good condition and is undergoing renovations.

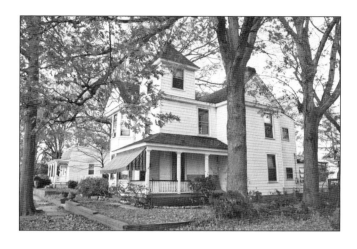

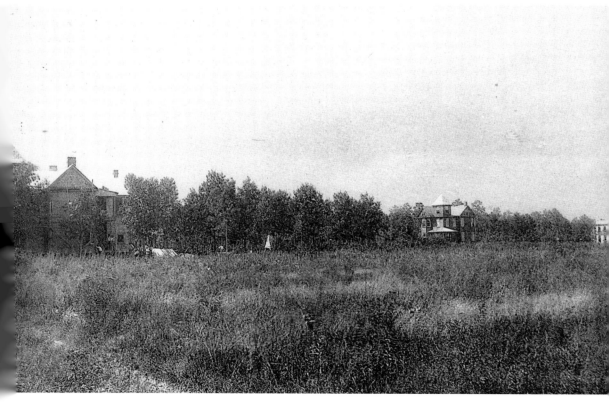

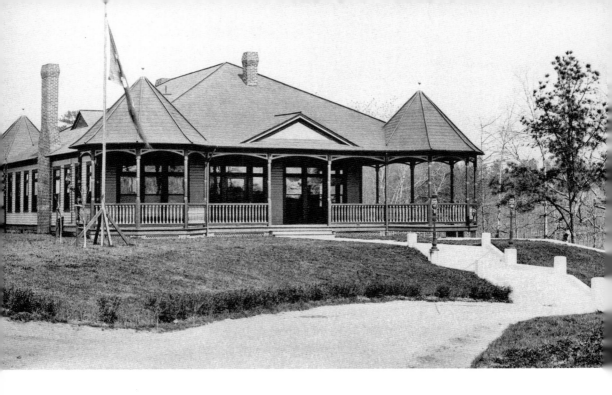

Originally this building, located in Richmond's far west end, was the Lakeside Wheel Club, founded c. 1884. Bicyclists would travel in from the city to enjoy this scenic landscape. A streetcar eventually connected this park to the city. The park was founded by tobacco merchant Lewis Ginter, who upon his death left the property to his niece Grace Arents. Arents turned this clubhouse into a convalescent home in 1913 and later into her own home. The building is now called the Bloemendaal House, after the family's German ancestry, and is used by Lewis Ginter Botanical Gardens for special events.

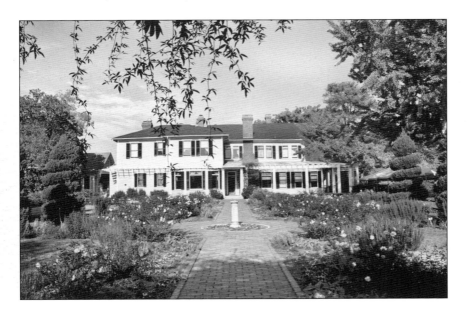

The Ginter House at 901 West Franklin Street was built *c.* 1888 by Harvey L. Page and William W. Kent for Maj. Lewis Ginter, who fought for the Confederacy during the Civil War. In the 1920s, the home became the site of Richmond city's first public library. Once it became too small for the library, it was purchased in 1931 by the College of William and Mary. Now the most recent owner, Virginia Commonwealth University (VCU), uses it as administrative space. Ginter's carriage house on this complex became the site of the college library until the current building at Floyd Avenue was built in the 1970s. The carriage house is now the site of VCU's Anderson Gallery of Art.

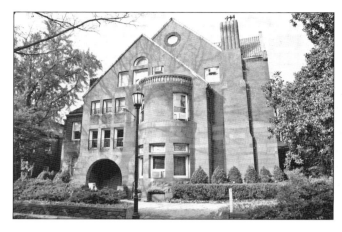

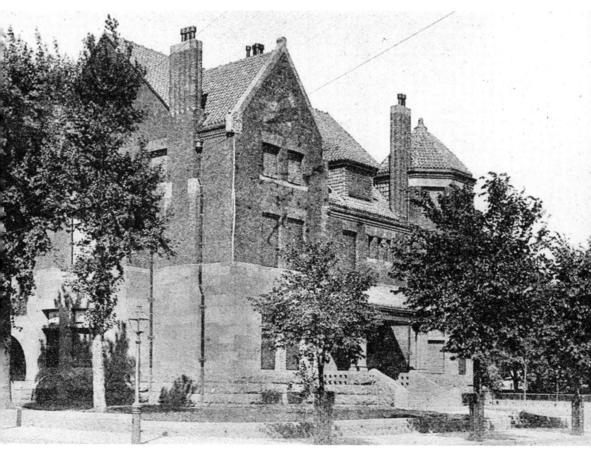

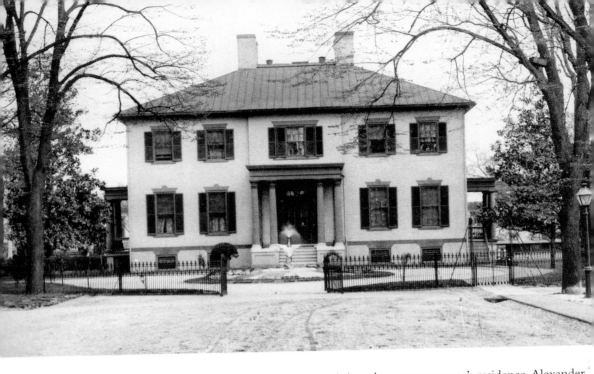

In February 1811, the Virginia General Assembly commissioned a new governor's residence. Alexander Parris, the Boston architect for this building, was paid $50 for his drawings. The project was not to exceed $12,000 in cost. Richmond's Governor's Mansion is the oldest still in use in the United States. The Marquis de Lafayette, Winston Churchill, and Queen Elizabeth were some of the many prestigious guests in this house. The latest restoration was completed in 2000 by the architect John Paul Hanbury and featured on the television program *Bob Vila's Home Again*.

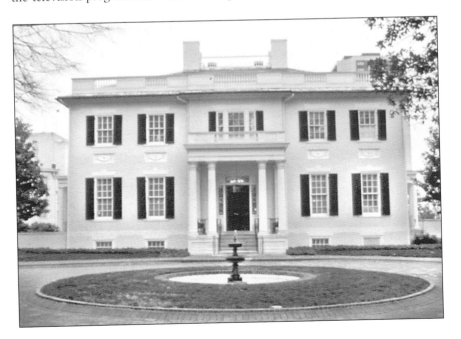

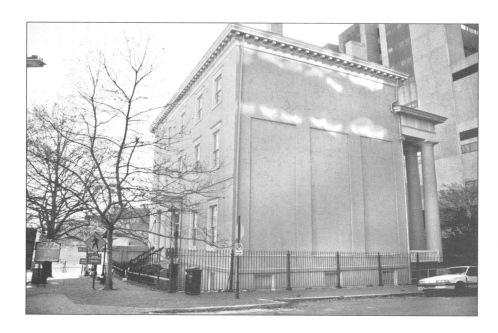

Originally this home at 1201 East Clay Street was built for Dr. John Brockenbrough around 1816. The design of the house is attributed to the architect Robert Mills. During the Civil War, it became the executive mansion for the president of the Confederate States, Jefferson Davis. After the war, it was used as a school until 1896, when the building became a part of the Museum of the Confederacy. Still a part of the museum, it is currently called the White House of the Confederacy.

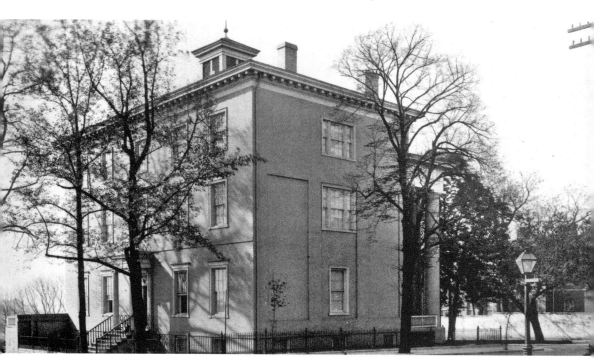

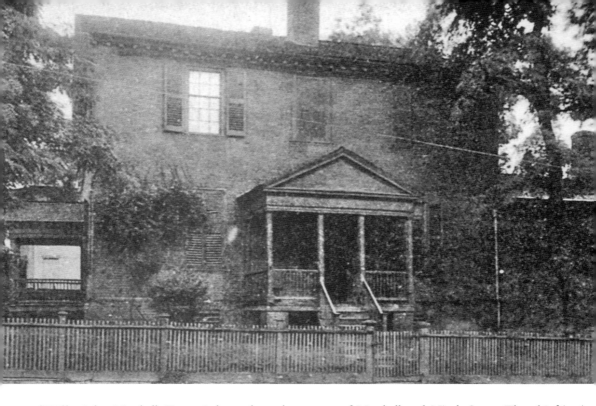

The John Marshall House is located on the corner of Marshall and Ninth Street. The chief justice occupied the home from 1795 to his death in 1835. John Marshall is buried in Shockoe Cemetery across from the Almshouse on Hospital Street. There would have been outbuildings on the original site for the laundry, stables, and kitchen. Marshall's home is three stories with a wine cellar in his basement. The John Marshall House was threatened with demolition in the early 20th century when a high school was built on this site. The John Marshall House was saved and given to the Association for the Preservation of Virginia Antiquities. The home is now a museum open to the public for tours.

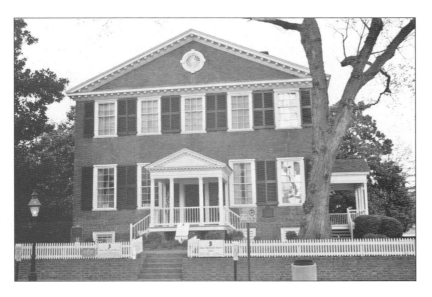

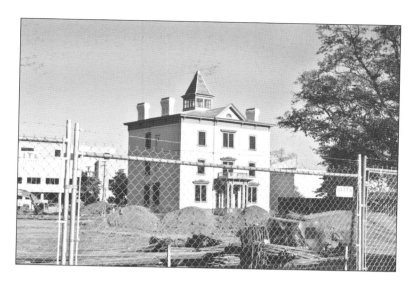

This house was built *c.* 1850 for Channing Robinson and his family on their farm. After the Civil War, around 1880, the home became the Robert E. Lee Confederate Soldiers Camp. The house is now a part of the Virginia Museum of Fine Arts (VMFA). The current photograph shows the construction site surrounding the home. The VMFA is undergoing an expansion project that will add gallery space and additional parking. After construction, the Robinson house will be used for museum office space.

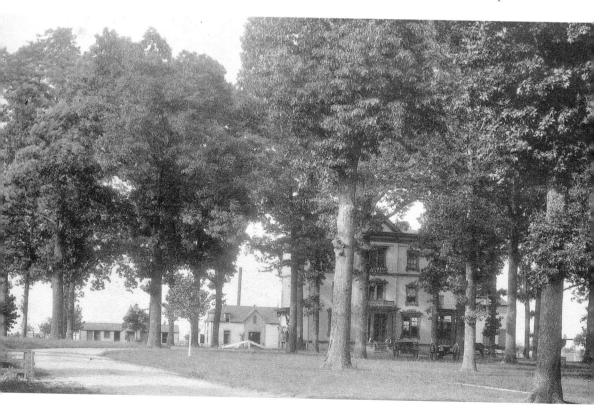

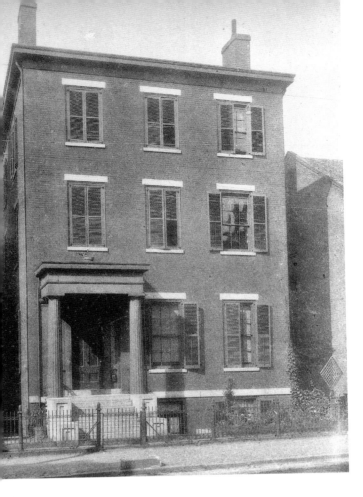

The family of Gen. Robert E. Lee occupied this row home, located at 707 East Franklin Street, during the Civil War. The home was first built in 1844 for Norman Stewart. He built five row homes on this street, and they were called Stewart's Row. The house was left to Norman Stewart's nephew John Stewart in 1856. He rented it to Gen. Custis Lee during the Civil War, and Gen. Robert E. Lee stayed at this home as well. In 1930, this was the headquarters of the Virginia Historical Society. Now the building holds office space and is used for social functions.

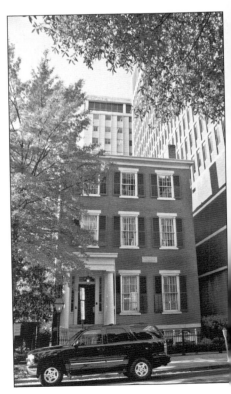

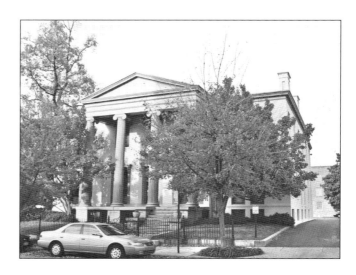

Located at 110 West Franklin Street, this home was built in 1845 for the Taylor family. William F. Taylor, who would later own the home after his father passed away, worked for the Bank of Virginia. The house was sold in 1883 to Peter H. Mayo, a tobacco merchant and Richmond philanthropist. Mayo remodeled the house, adding an extension from the Jefferson Street side of the house. In 1923, the home was given to the Diocese of Virginia and became known as the Mayo Memorial Church House.

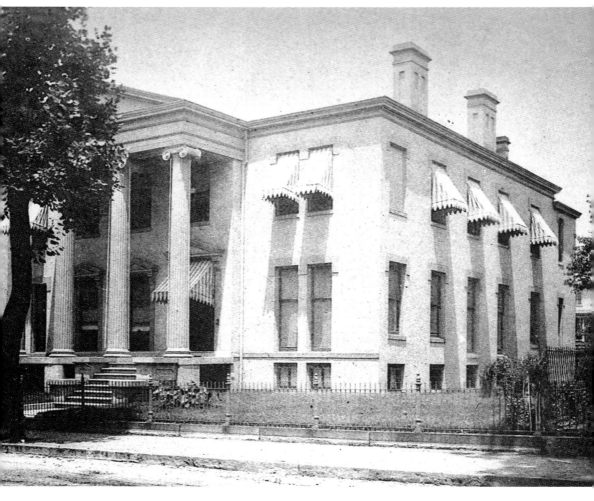

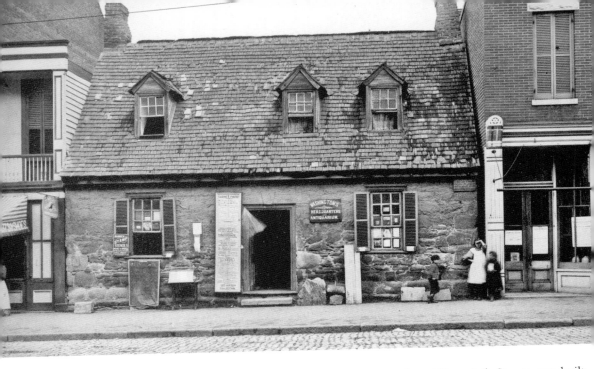

The Old Stone House, situated on Main Street between Nineteenth and Twentieth Streets, was built around 1750 for Jacob Ege, a German tradesman. This is Richmond's oldest home still standing. In the 1890s, visitors would come to see the building, believing it was George Washington's headquarters. However, there are no records to prove that Washington ever visited Richmond during the Revolutionary period. In 1922, the house became a museum dedicated to Edgar Allan Poe. Today the home is open to the public for tours.

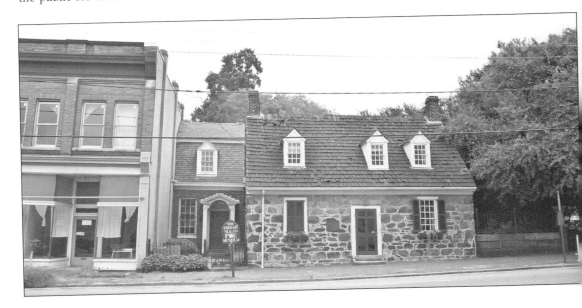

James B. Pace was in the tobacco business then later was the president of Planters National Bank. Planters National Bank was established in 1865 and stems from the Farmers Bank of Virginia of 1812. From 1865 to 1881, Pace lived at 205 North Nineteenth Street in Shockoe Valley. His late-19th-century home still stands at 100 West Franklin Street. The house was built 1876–1879 by an unknown architect. The home is noted for its paneled windows, a decor element not often seen in architectural history. In 1908, the building was renovated into an apartment house. The house is currently being leased for commercial space.

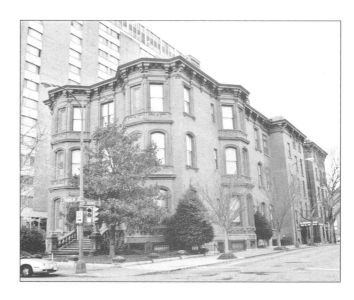

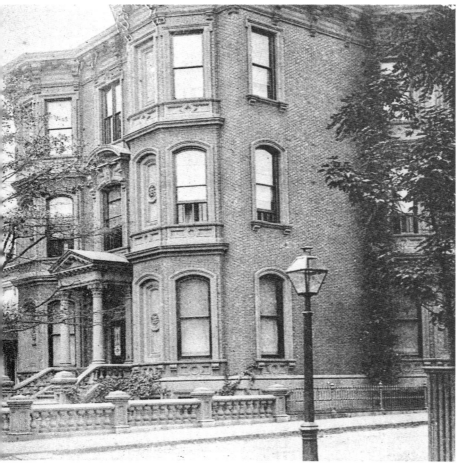

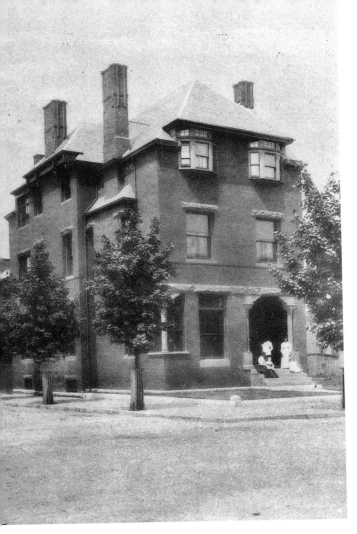

The home of Parker T. Conrad, a tobacco manufacturer, stood at 900 Floyd Avenue. Conrad was an associate of JMC and Sons, a leaf tobacco broker and manufacturer. His office was at Twenty-seventh and Thirteenth Street. The site of his home is now Virginia Commonwealth University's Monroe Park Campus library. The library is named after the 1920s Richmond writer James Branch Cabell. Cabell is noted for his controversial novel *Jurgen* (1919). The library opened in 1970, and the top three floors were added in 1975.

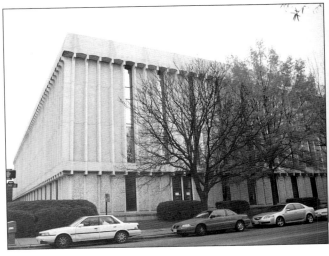

At 324 South Fourth Street stood Pratt's Castle, the home built in 1853–1854 for Englishman William A. Pratt. Pratt was a 19th-century Renaissance man and studied architecture, engineering, and the process of daguerreotype at the University of Virginia. The home had a great view of the James River. Looking like a medieval castle, this home was the most unique house in the city. Much to the dismay of preservation groups, the building was demolished in the 1950s. Today the Ethyl Corporation Complex stands on this spot.

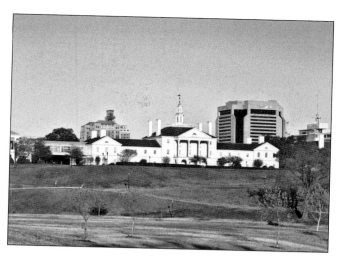

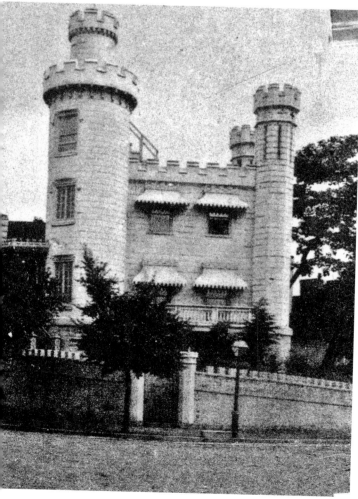

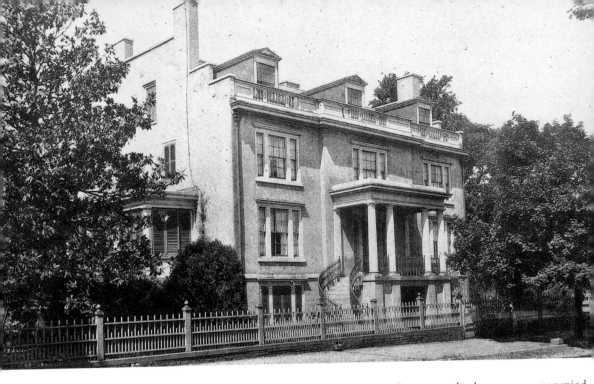

In the Richmond neighborhood Church Hill, at 2311 East Grace Street stood a home once occupied by Elizabeth Van Lew, a spy for the Union army during the Civil War. The home was originally built for Dr. John Adams in 1802, who later became mayor of Richmond. Although many said that Van Lew helped slaves escape from a hidden room in her house, no room was found during the home's demolition in 1911. Bellevue Elementary School was built on this site around 1912.

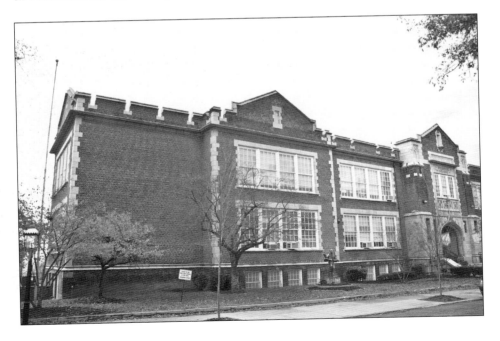

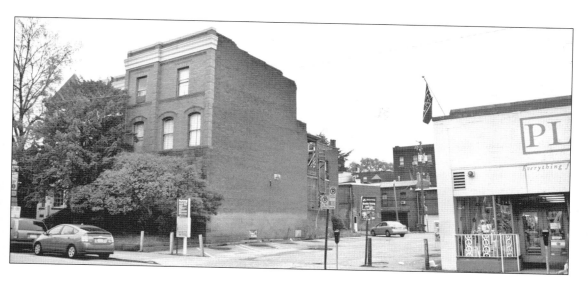

Wirt E. Taylor was in the wholesale grocer business, and his business was located at 1315 East Main Street. His home, which no longer stands, was situated at 925 or 926 West Grace Street just a short distance from the home of Lewis Ginter. Both homes share the use of rusticated brownstone, a popular late-19th-century building material. The area is now a commercial street catering to the university students who live in this area. Nineteenth-century row homes have been turned into shops, and the street is mixed with 20th-century storefronts.

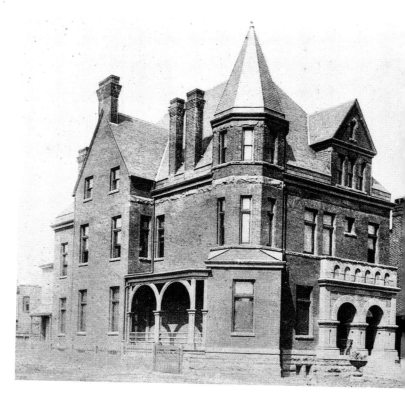

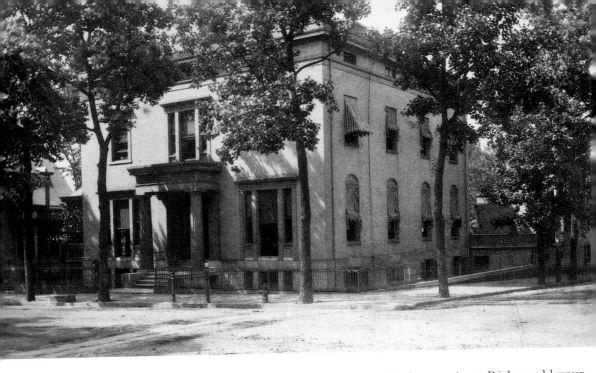

The Westmoreland Club was built around 1840 for Robert Stanford, a prominent Richmond lawyer. The location of the club was 601 East Grace Street. The house was sold to the Westmoreland Club in 1879. The club was established for social and literary pursuits. The first home used by the club in 1877 was at 707 East Franklin Street, war residence of Robert E. Lee. In 1920, the club disbanded, and in 1937, the house was demolished. This is now the site of the Carpenter Center for the Performing Arts.

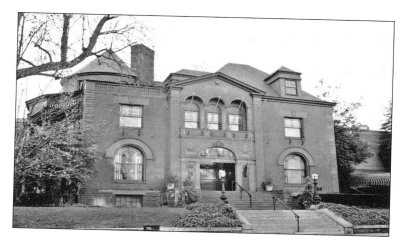

The Commonwealth Club was designed in 1890 by New York architects Carrere and Hastings. The building has been expanded throughout the 20th century but still retains much of its 19th-century facade. The social club is an extension off of the 1867 Richmond Club and was founded on March 3, 1890. The club has a gentlemen's only floor that includes a gymnasium, sauna, baths, barbershop, and restaurant. The building stands on the 400 block of West Franklin Street, near the historic Jefferson Hotel. This street used to boast rich homes west from Capitol Square. The street is now a mixture of commercial and residential properties.

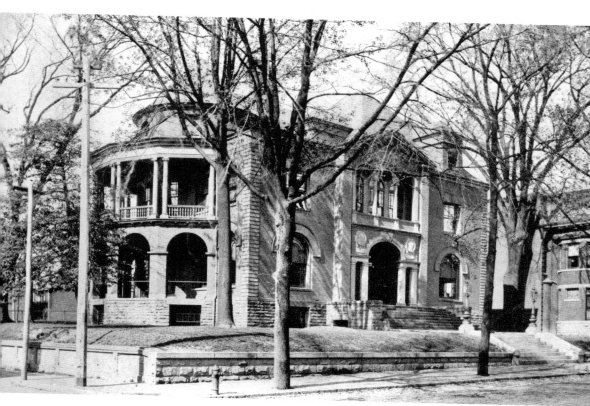

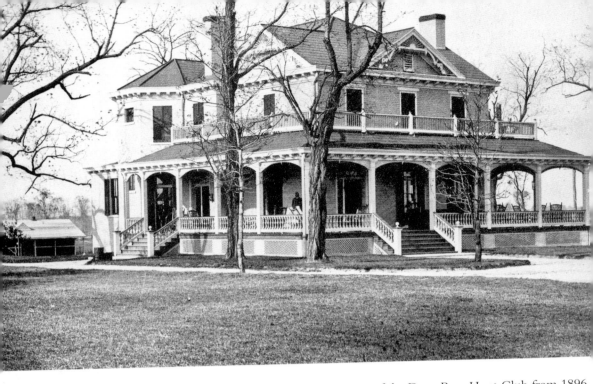

Rosendale Lodge, located in Ginter Park, was the clubhouse of the Deep Run Hunt Club from 1896 to 1910. Ginter Park was one of Richmond's first suburbs founded by Maj. Lewis Ginter. Many of the building projects during the 1890s were funded by Ginter, whose wealth came from tobacco. In 1947, the Hunt Club relocated to Goochland, west of Richmond. The more recent photograph shows the current location of the clubhouse. The Deep Run Hunt Club originated the popular Strawberry Hill horse racing event now held at Colonial Downs in New Kent, Virginia.

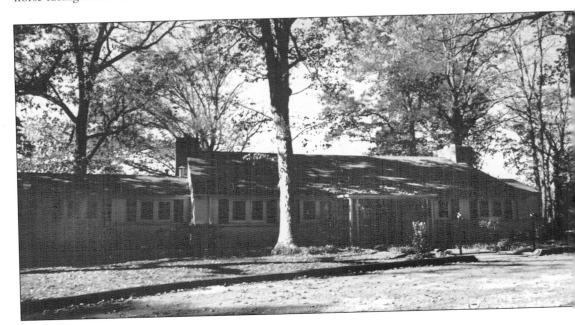

Chapter 2

MONUMENTS, PARKS, AND CEMETERIES

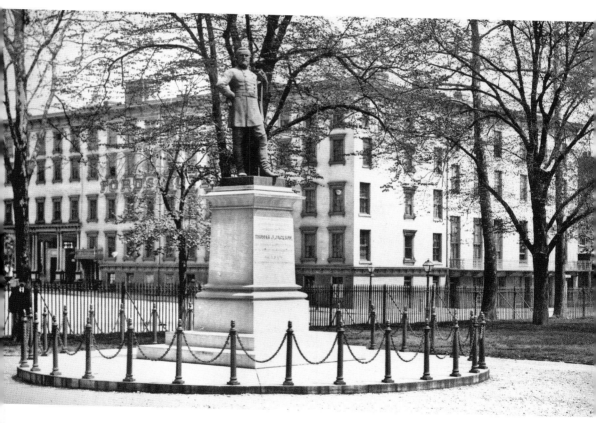

The bronze pedestrian sculpture of Stonewall Jackson was designed by the Irish sculptor John H. Foley. The Sculptor also designed the Prince Consort Albert Memorial in London's Hyde Park. The Jackson statue was commissioned in 1865 by British gentlemen who thought it important to honor the admired Confederate war hero. The sculpture is believed to be the only Confederate monument in America erected with British funds. The sculpture was not unveiled until a decade later in 1875. The statue can still be seen in the courtyard of Capitol Square. Capitol Square is located at Ninth and Grace Streets.

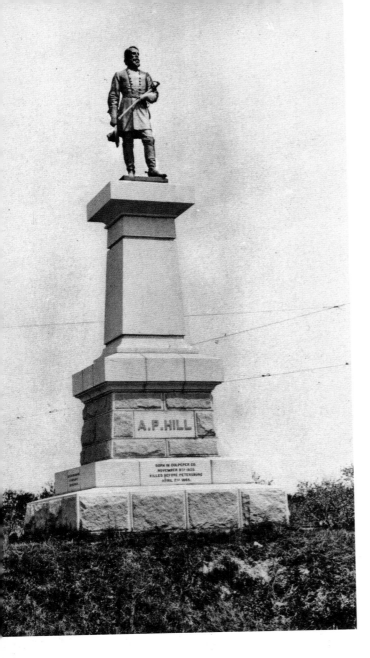

A bronze statue to Confederate lieutenant general Ambrose Powell Hill was placed at the intersection of Laburnum Avenue and Hermitage Road on May 30, 1892. Hill took over Stonewall Jackson's troops at Chancellorsville after Jackson was wounded. A. P. Hill was originally buried in Hollywood Cemetery in 1867. However, before 1892, his remains were moved from Hollywood to the site of the future monument. The statue and the remains of A. P. Hill are still at this intersection. Today this is a busy street in the residential area known as Ginter Park.

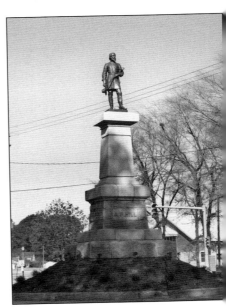

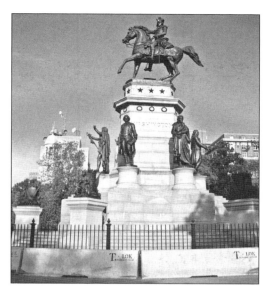

George Washington's equestrian statue is located at the entrance of Capitol Square. This monument honors Washington and six other historical figures. Surrounding Washington are the statues of Andrew Lewis, Revolutionary War general; Patrick Henry, first governor of Virginia; George Mason, author of Virginia's 1776 Declaration of Independence; Thomas Jefferson, third president of the United States; Thomas Nelson, both Virginia governor and commander-in-chief of the Virginia Militia in 1781; and Chief Justice John Marshall. The monument was designed by American sculptor Thomas Crawford and was unveiled on February 22, 1858.

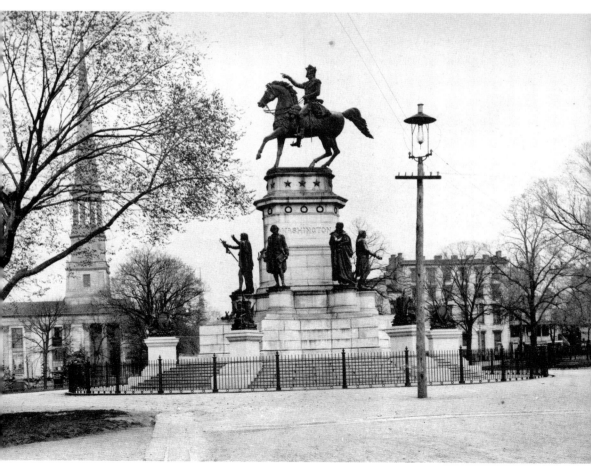

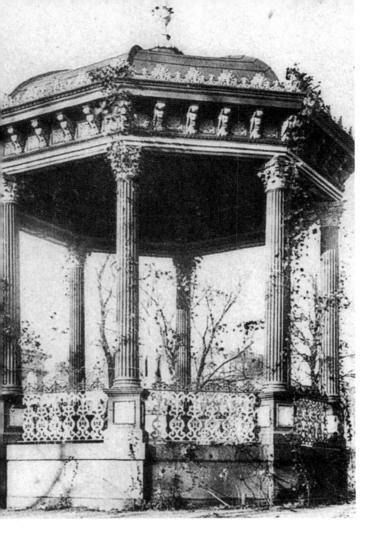

On April 12, 1860, a marble statue of Henry Clay, Virginia native and Speaker of the House during the Missouri Compromise, was placed on Capitol Square in an iron pavilion near the bell tower, which still stands near the Bank Street entrance today. The statue was inside an iron gazebo. Because of weathering and vandalism, the statue was moved inside the Capitol. The "then" photo shows the empty gazebo, which no longer stands in Capitol Square. The Henry Clay statue is now on display at the Library of Virginia.

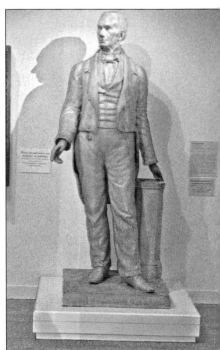

Shockoe Hill was chosen as the site for the state Capitol building. The landscape was first planned around 1816 by the French architect Maximilian Godefroy. Little of that plan, which was geometrically structured, was actually developed. In 1853, the landscape architect John Notman redesigned the plan to include much of what is seen today. In the foreground of the pictures is a wrought-iron fountain located near the bell tower and the Bank Street entrance. Capitol Square is a popular place for strolls and picnics.

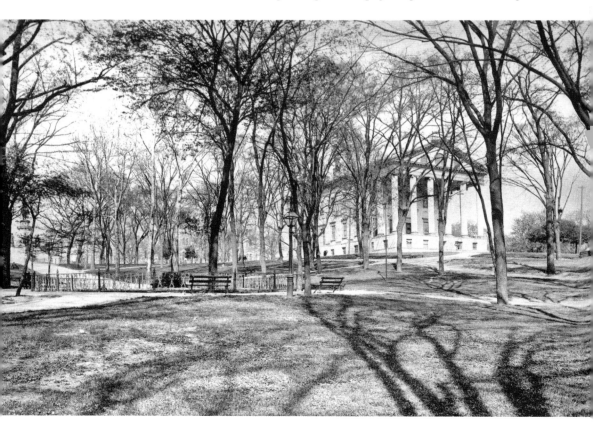

During the Civil War, Belle Island was a prison camp for Union soldiers. Thousands of soldiers were held captive on an island about a mile in length. As the war progressed and the number of prisoners increased, conditions on the island worsened. Clothing and food was limited and disease spread. Union officers were at Libby Prison, a building that was Luther Libby's warehouse before the war. Conditions inside the warehouse prison were not much better then the island, where over 200 men were confined in one room. Union soldiers did try to escape from Belle Island but were captured. Today the 54-acre island is a recreational park.

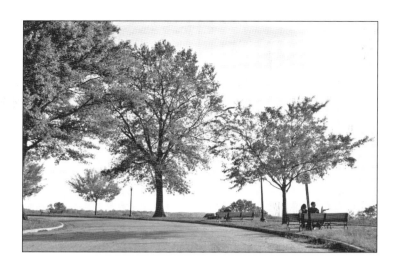

The city acquired the land for Chimborazo Park in 1874. Chimborazo is the name of the highest peak in Ecuador. During the Civil War, Chimborazo Hospital, which stood near this site, was one of the largest Confederate military hospitals in the South. The park is located in the Church Hill neighborhood. Church Hill is filled with 19th-century townhomes. Elmira Shelton, Poe's fiancée at the time of his death, lived in this neighborhood. Her home still stands at 2407 East Grace Street. In 1958, the Richmond National Battlefield Park Association moved its headquarters to Chimborazo Park, which offers a beautiful view of the city.

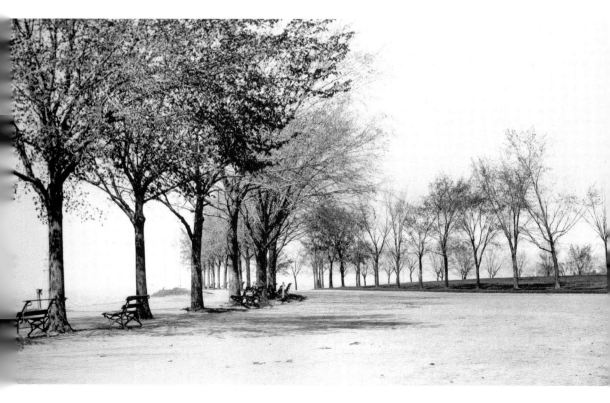

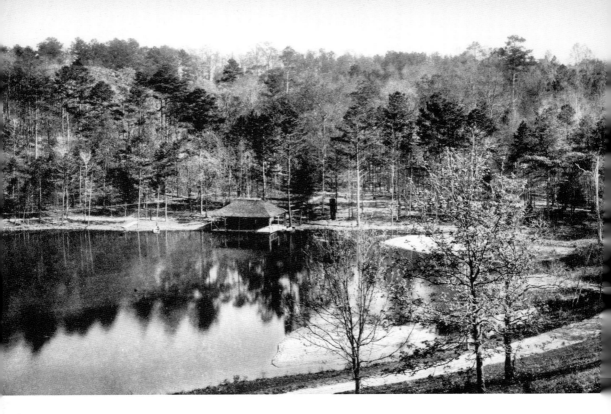

Forest Hill Park is located in the south side of Richmond between Forest Hill Avenue and Riverside Drive. In the 19th century, the 97-acre park was a bathing resort. The neighborhood surrounding the park is called Westover Hills. Westover Hills is named after William Byrd's plantation, Westover. The neighborhood lies south of Richmond overlooking the James. Developed in the 1920s and 1930s, the neighborhood is well maintained today. Forest Hill Park is still an attractive site with many rustic paths for walking or bicycling.

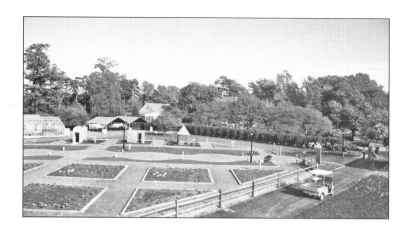

In the early 20th century, Lakeside Park was established by Lewis Ginter, one of Richmond's wealthiest patrons during this time period. Originally the park was used by a bicycling club, which would ride in from the city for a retreat. The park included a petting zoo and what was probably one of Richmond's first golf courses. Boating in the summer and skating in the winter were also available. Later the wheel club became a country club. This is now the site of Lewis Ginter Botanical Gardens. Pictured in this recent photograph is the Children's Garden, opened in 2005.

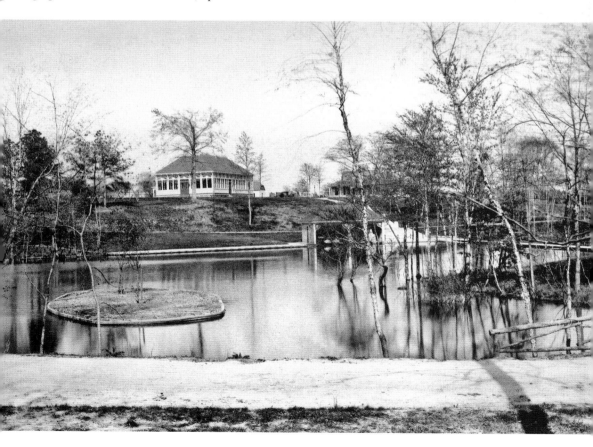

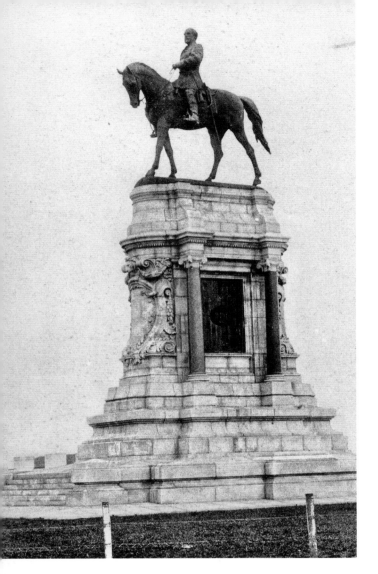

The Robert E. Lee statue on Monument Avenue was dedicated in 1890. Before this street was lined with beautiful 1920s homes, the statue was surrounded by tobacco fields. It was designed by the French sculptor Marius Jean Antonin Mercie, who used several Lee relics to create a realistic representation of the general. Among the relics used were his death mask and boots. The statue still stands at the corner of Monument and Allen Avenues. There are five other monuments on this historic avenue, dedicated to J. E. B. Stuart, Jefferson Davis, Stonewall Jackson, Matthew Fontaine Maury, and Arthur Ashe.

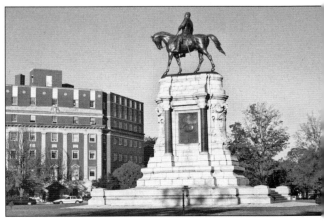

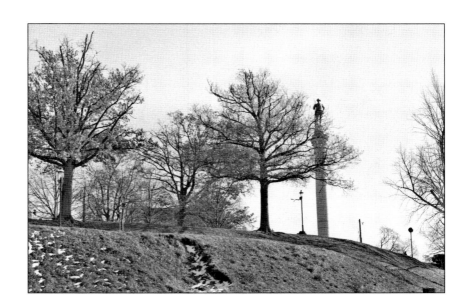

L ibby Park was created in the mid-19th century in Richmond's historic Church Hill neighborhood. The park was named after Luther Libby, a Richmond grocer, whose home was nearby. Libby owed a factory that would be used during the Civil War as a prison for Union officers called Libby Prison. The park is the site of the Confederate *Soldiers and Sailors* monument. There is a majestic view of the city from the ridge of this park. Comparing the photographs, the area has not changed much since its creation over 100 years ago.

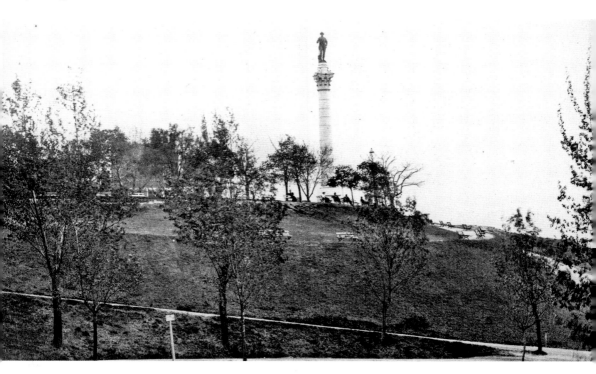

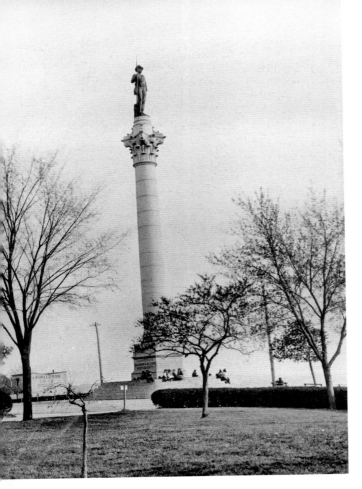

In 1894, a 100-foot monumental Corinthian column called *Soldiers and Sailors* was erected in Libby Park to honor the enlisted soldiers and sailors who fought for the South in the Civil War. The monument is said to be a copy of Pompey's Egyptian pillar. On top of the column is a statue of a soldier crafted by Richmond sculptor William Ludwell Sheppard, who created the Howitzer statue in Harrison Street Park as well. The monument is still located at the corner of Twenty-ninth Street and Liberty Terrace in Church Hill.

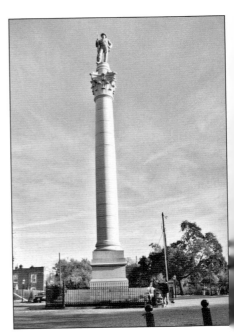

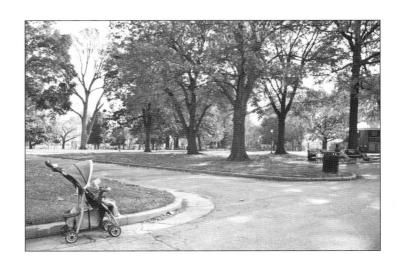

From 1851 to 1859, the city acquired 7.5 acres to create an area that came to be known as Monroe Park. After the Civil War, the park was just a dirt field; some of Richmond's first baseball games were played here. The park was in great need of improvements in the 1870s. The fountain was donated by Union colonel Albert Ordway, who was on the Richmond council to rehabilitate the park. Monroe Park is now in the middle of Virginia Commonwealth University's urban campus. Students walk through this park on their way to classes.

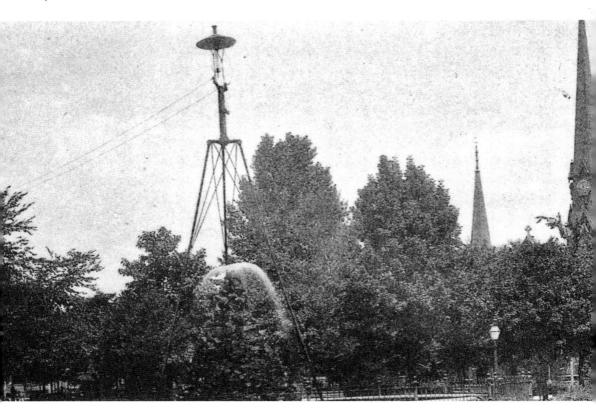

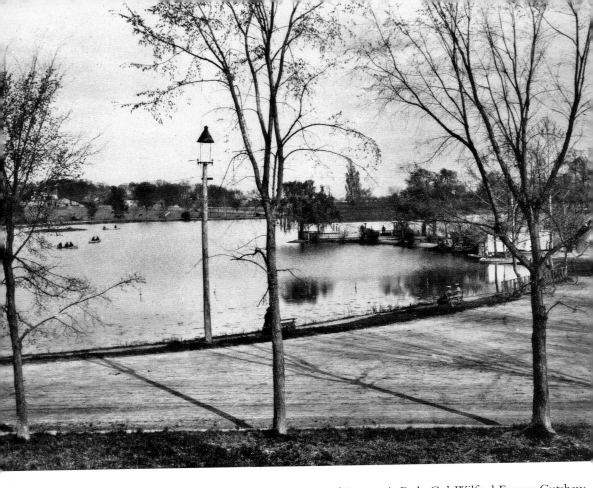

In 1885, the city established 300 acres for the creation of Reservoir Park. Col. Wilfred Emory Cutshaw, city engineer from 1873 to 1907, is greatly responsible for the development of this recreational site. Cutshaw made efforts to acquire as much land as possible for Richmond's city parks. In the 1890s, Richmonders could get to Reservoir Park by streetcar. The park was a favorite swimming spot for many decades. Still a recreational park, there is no swimming today and the name has changed to Byrd Park.

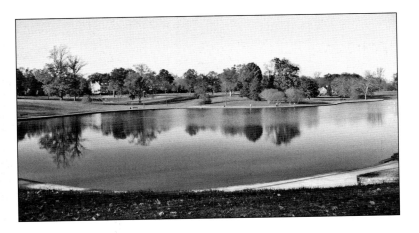

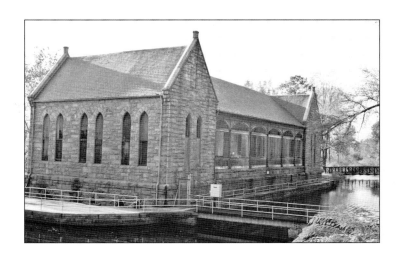

The Byrd Park Pump House was built in 1883 for both utilitarian and social purposes. City engineer Colonel Cutshaw thought the building's location ideal for the dance hall built on the second floor. The pump house was located on the canal system so guests could reach it by canal boat. The pump house was abandoned in 1924, and in the 1950s, the structure was slated for demolition. First Presbyterian Church purchased the building for $1 in the 1950s. Now the Historic Richmond Foundation is raising funds for the preservation of the pump house.

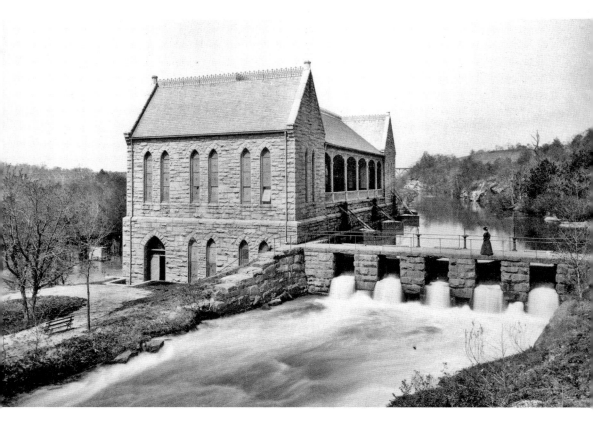

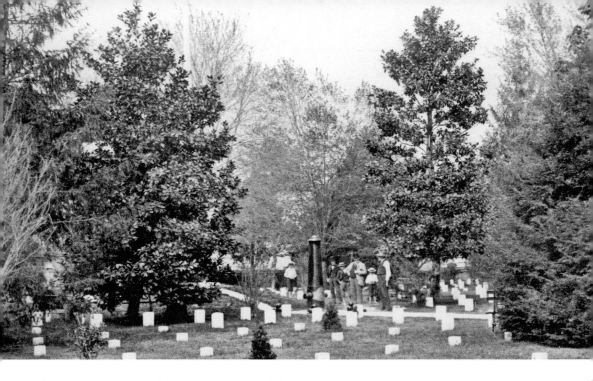

Seven Pines National Cemetery is named for the seven pine trees planted along the surrounding wall. The cemetery is located at 400 East Williamsburg Road in Sandston, Virginia. Before the Civil War, this area about eight miles southeast of the city was open farmland. The battle of Fair Oaks, also known as the Battle of Seven Pines, was fought on this site. Over 1,000 unknown Civil War soldiers are buried at this site. Today the cemetery is managed by the National Cemetery Association.

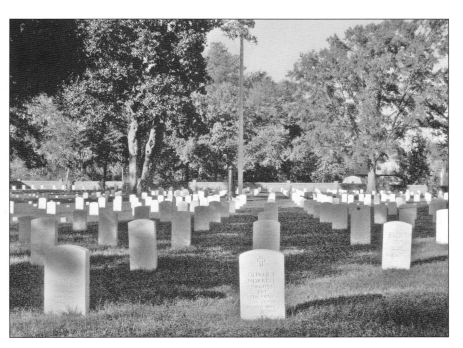

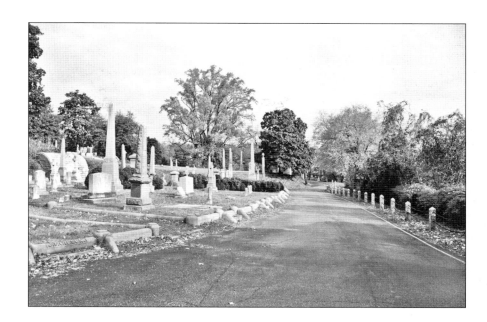

Hollywood Cemetery was established in 1849 at 412 South Cherry Street by the architect John Notman, who also laid out the landscape of Capitol Square. Hollywood is named after the many holly trees in the cemetery's landscape. In the 1940s, Richmond's Shockoe Cemetery at Second, Fourth, and Hospital Streets was almost filled to capacity. Hollywood Cemetery was created during the picturesque movement, which sought to integrate utilitarian spaces with the natural landscape. The cemetery, which is nonprofit and owned by its lot owners, has done well at maintaining the landscape and monuments of this historic site.

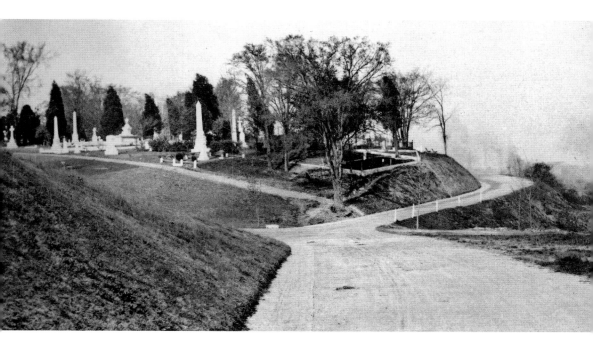

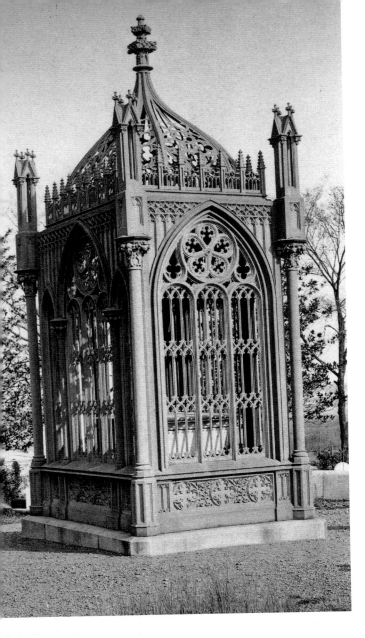

The tomb of James Monroe in Hollywood Cemetery was designed by the German architect Albert Lybrock, who designed the Mozart Academy. President Monroe was originally buried in New York, where he was living when he passed away. In 1858, Virginians lobbied to create a monument for the president in his home state. His remains were moved, and a monument was installed in 1859 on a hill that overlooks the James River. Pres. John Tyler and Pres. of the Confederacy Jefferson Davis are also buried here.

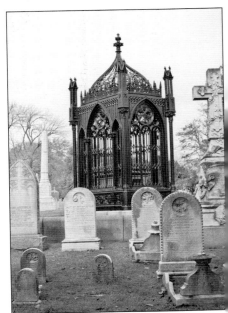

In 1869, the Confederate Memorial was erected in Hollywood Cemetery to memorialize the 18,000 soldiers' graves at this site. The pyramid monument stands 90 feet tall and is made of marble granite with no mortar. In trying to complete the monument, the crane could not reach the top to place the capstone. The call for a volunteer to climb the monument and manually place the capstone was issued. A navy prisoner accepted the offer knowing there was a great chance of fatality. The prisoner was successful in placing the capstone and was released for his efforts. When one compares the two photographs, ivy used to cover the monument.

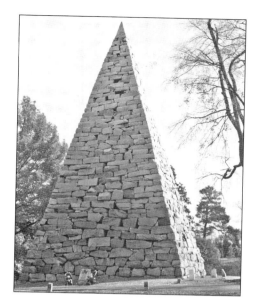

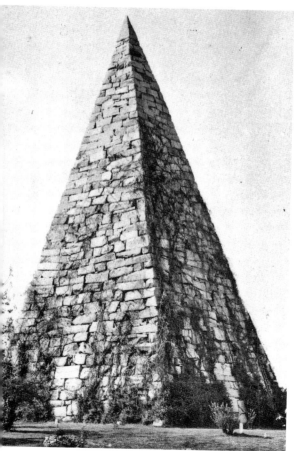

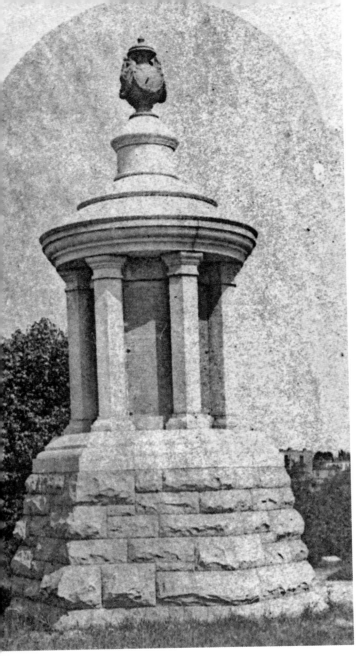

General George Edward Pickett was buried in Hollywood Cemetery with his men in 1872. His wife, LaSalle Pickett, who died in 1931, was not allowed to be buried next to her husband because the cemetery board feared that similar requests would come from other Confederate families. LaSalle was cremated and ashes were housed in Abbey Mausoleum near Arlington National Cemetery. In 1998, her ashes were moved to Hollywood Cemetery and buried in front of her husband's memorial. Another notable Confederate, cavalry general James Ewell Brown Stuart, is also buried in Hollywood.

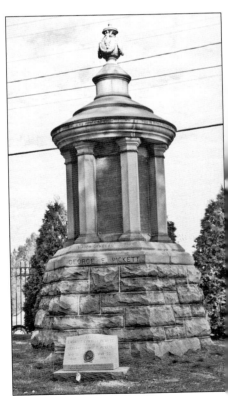

Chapter 3

CHURCHES AND SCHOOLS

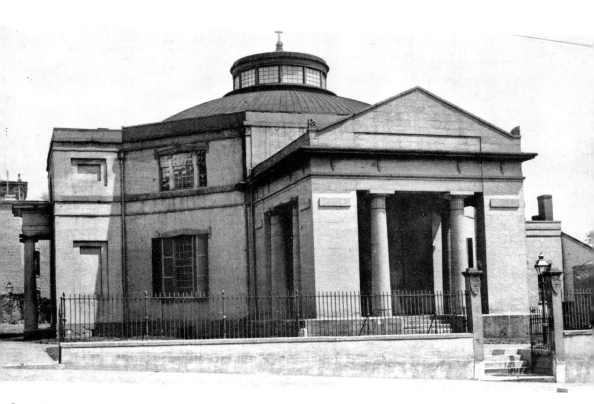

At 1224 East Broad Street stands Monumental Church. The church was designed around 1812 by the architect Robert Mills, who is also attributed with the design of the White House of the Confederacy. The building is a memorial to the 72 individuals who died in a tragic theater fire on December 26, 1811. The church was an Episcopal parish until 1965, then it was used as a chapel for the Medical College of Virginia. The church is now undergoing restoration funded by the Association for the Preservation of Virginia Antiquities.

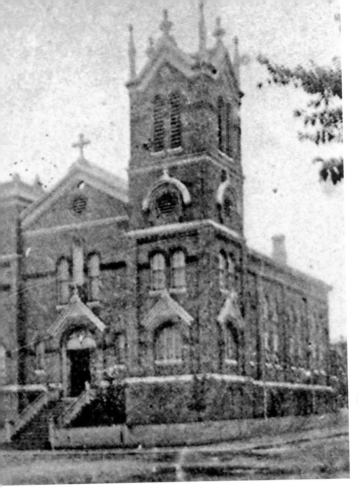

The Sacred Heart Church stood at Brunswick Street and Floyd Avenue. There is now a university building on this site. The church was built in 1887 for the Catholic church. Even though the land for a new building to be called the Cathedral of the Sacred was purchased in 1867, the building took time to overcome financial and social opposition. The new Sacred Heart Cathedral was built between 1903 and 1906 with funds from Thomas Fortune Ryan, financier and Virginia native. The New York architect Joseph H. McGuire designed the building, which now stands at Laurel Street and Floyd Avenue.

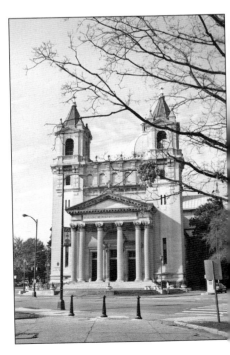

In 1841, First Baptist Church was designed by the Philadelphia architect Thomas U. Walter, who is known for his design for the U.S. Capitol dome. This building is the only survivor of the 10 buildings Walter designed for Virginia. During the Civil War, the building was used as a hospital. Since the 1930s, the building has been used by the Medical College of Virginia as a student center. The building, located at the corner of Broad Street and Twelfth Street, had its belfry removed in 1938 and has since undergone several expansions.

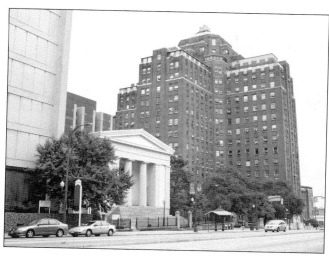

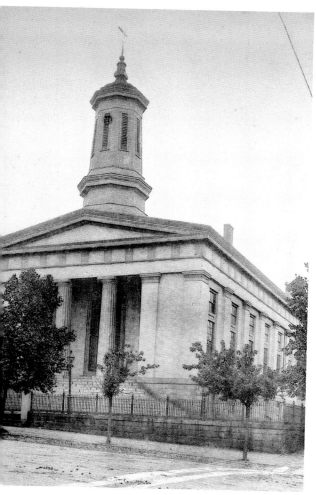

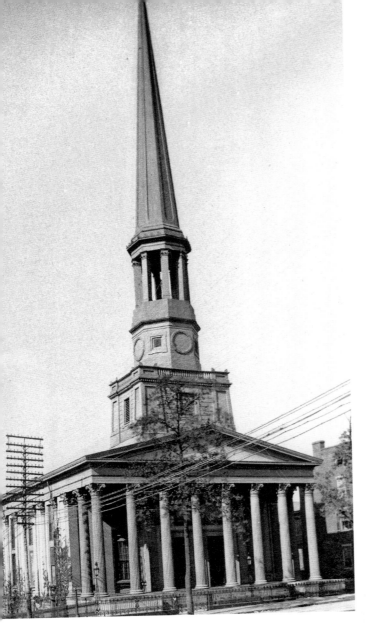

St. Paul's Episcopal Church was built in 1844–1845 and designed by the Philadelphia architect Thomas S. Stewart. Stewart also designed the Medical College's Egyptian Building. The church, which is located at 815 East Grace Street, had a tall Gothic spire that was removed. Pres. of the Confederacy Jefferson Davis and Robert E. Lee worshiped here during the Civil War. It was here that President Davis received news from General Lee of the need to evacuate Richmond. The church now contains several stained-glass windows from Tiffany Studios.

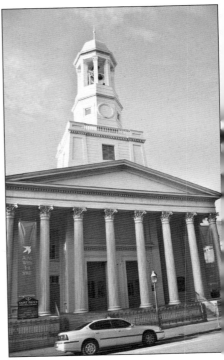

St. Peter's Roman Catholic Church at 800 East Grace Street was built in 1834 under the direction of Fr. Timothy O'Brien. St. Peter's is Richmond's oldest Roman Catholic church. German and Irish immigrants were some of the first members of the church. This church served as the Richmond Cathedral of the Catholic Diocese from 1837 until the consecration of the Cathedral of the Sacred Heart in 1906. Today the church continues to function as a place to worship in the city.

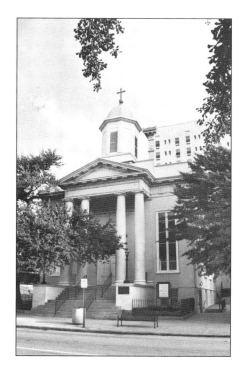

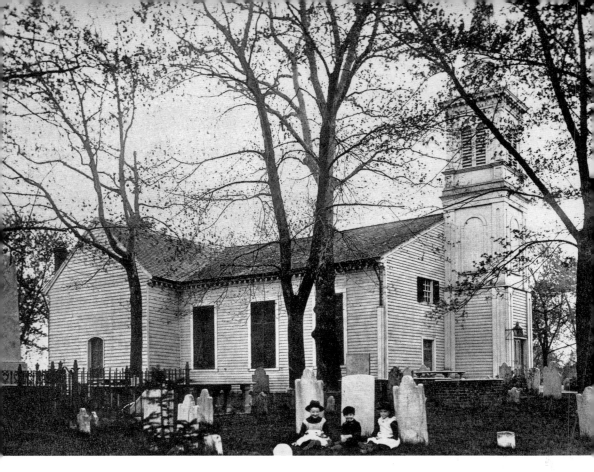

St. John's Episcopal Church at East Broad and Twenty-fifth Streets marks the site of Patrick Henry's March 23, 1775, "Give me Liberty or Death" speech. The Virginia General Assembly met here, and the attendees included George Washington, Thomas Jefferson, and George Mason. The church was built between 1739 and 1741 by Richard Randolph on land donated by William Byrd II, founder of Richmond. The church has been renovated several times over the years. George Wythe, signer of the Declaration of Independence, and Elizabeth Allan Poe, mother of Edgar Allan Poe, are buried in the courtyard cemetery.

St. Mary's German Catholic Church stood at Marshall Street between Third and Fourth Streets. The church was organized in 1843 for the German-speaking Catholics of Richmond city. In 1852, a school was founded under the direction of the church, and in 1860, the church was the site for the Richmond diocese. The church was demolished in the 1900s and is now the site of the 700,000-square-foot Greater Richmond Convention Center. Many historic buildings were sacrificed for the building of the convention center and the highway ramps in this part of the city.

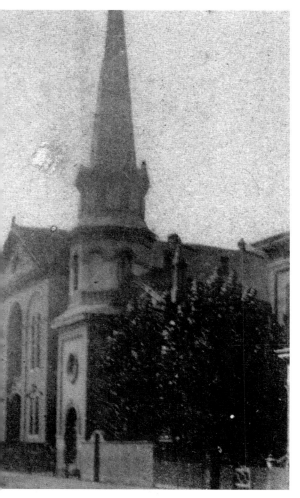

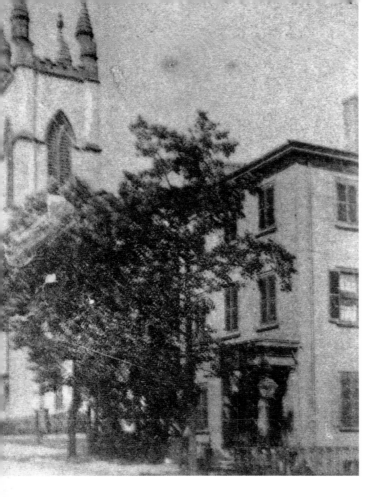

Second Presbyterian Church, located at Fifth and Main Streets, was organized on February 5, 1845. The Gothic church was designed by the New York architect Minard Lafever, and the church was completed in 1848. The church was one of the first in Richmond to have gas lighting. The pew Stonewall Jackson would visit during the Civil War is marked with a small brass plaque. Next to the church is the Virginia Building, designed by Noland and Baskervill and built in 1906 for the Virginia State Insurance Company. The building now holds office space for the church and other companies.

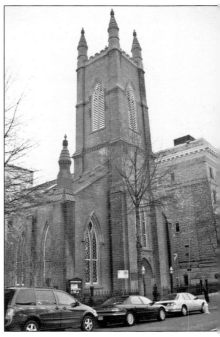

The Egyptian Building at College and Marshall Streets was designed by the Philadelphia architect Thomas S. Stewart. Stewart also designed Richmond's St. Paul's Episcopal Church, 1843–1845. The building was originally built for Hampden-Sydney College's medical department in the 1840s. In 1938–1939, the architectural firm Baskervill and Son added a neo-Egyptian auditorium to the interior. The building is now used by the Virginia Commonwealth University School of Medicine. A statue of Hippocrates presented by the Virginians of Greek Ancestry stands in the foreground of the recent photograph.

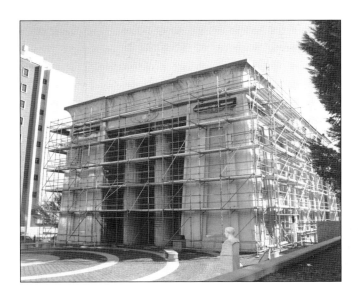

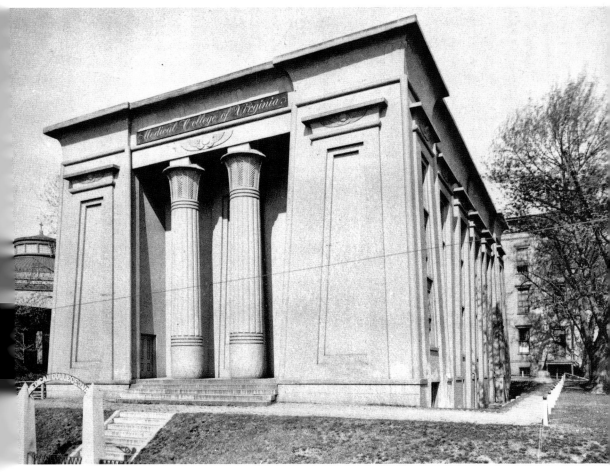

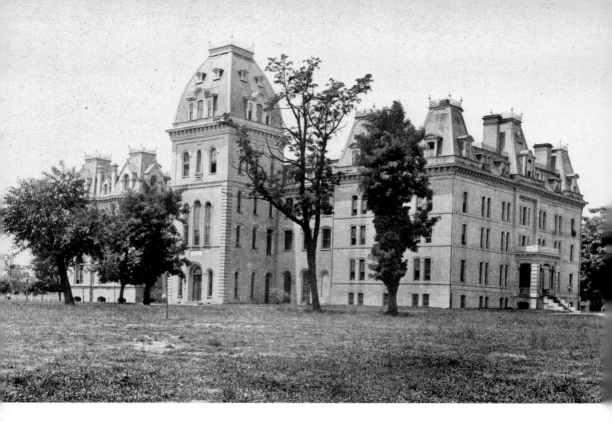

Richmond Baptist College was founded in the 1830s by the Virginia Baptist Educational Society. In 1834, the first president of the school was Robert Ryland, who was also the pastor at First African Baptist Church. The construction of the college's main building, pictured here, began in 1855. The building was designed by Thomas Alexander Tefft, who was also the architect for the Richmond Female Institute. Richmond College covered 13 acres in the city off of Grace Street. The University of Richmond can trace its roots back to the Baptist College. Today the gateposts that marked the entrance to the college remain at Lombardy and Ryland Streets.

The Richmond Female Institute building was designed in the 1850s by Thomas Alexander Tefft and stood at Tenth, Marshall, and Clay Streets. The institute was a boarding and day school for young ladies from kindergarten through college. The founders of the institution wanted to create a program similar to the University of Virginia. Richmond Female Institute merged with the University of Richmond in 1914. The building was destroyed by fire in 1924. Standing at this location now is the City Department of Social Services.

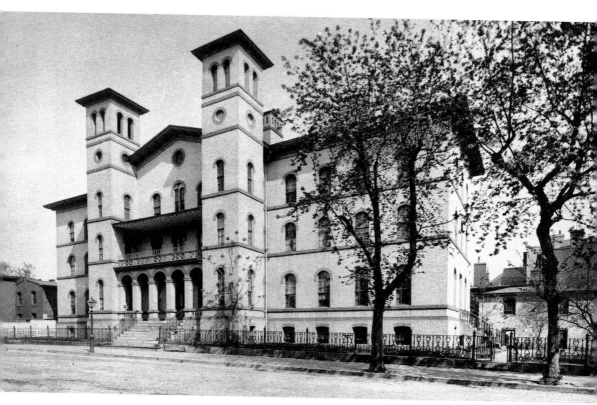

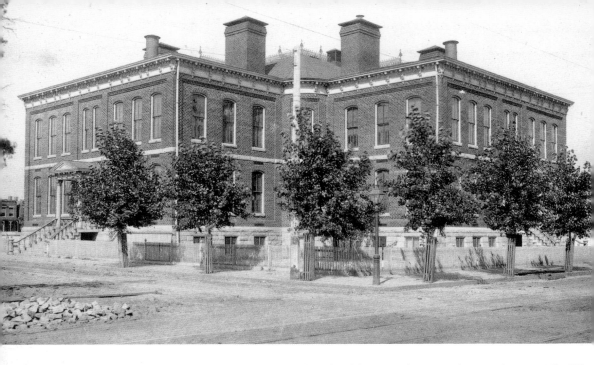

In the 1880s, children were denied access to public school because there wasn't enough space. The West End High School was built in 1886 to fulfill that need. The school was located at 1520 West Main Street. The school was later named after Stonewall Jackson. The building suffered fire damage in 1990 but was renovated successfully into restaurant and office space. The high school had a twin named after John Marshall, which stood in Shockoe Valley; it was demolished in 1972. The West End High School building is now the Jackson Professional Center.

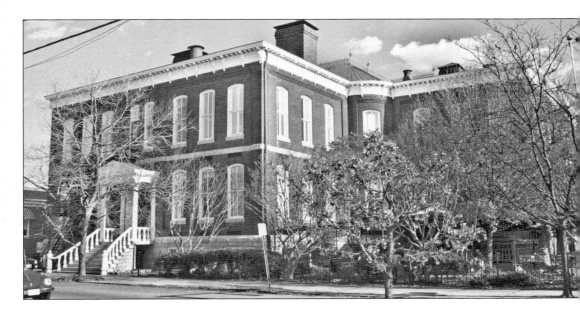

STREETSCAPES
AND LANDMARKS

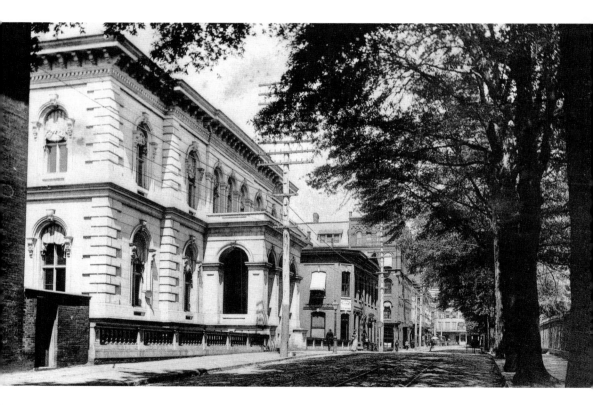

Richmond's Bank Street at Ninth is pictured here. Bank Street faces Capitol Square Park and stretches just from Ninth to Twelfth Street. In the 1890s, the building with the arched porch was the post office and U.S. Custom House. The custom house was one of the only buildings on Main Street not destroyed in the 1865 evacuation fire. On April 2, 1865, Richmond was evacuated due to Grant's army's attacks on the Confederate line at Petersburg. Confederates set fire to Richmond as they were leaving to insure the Union would not gain Confederate documents.

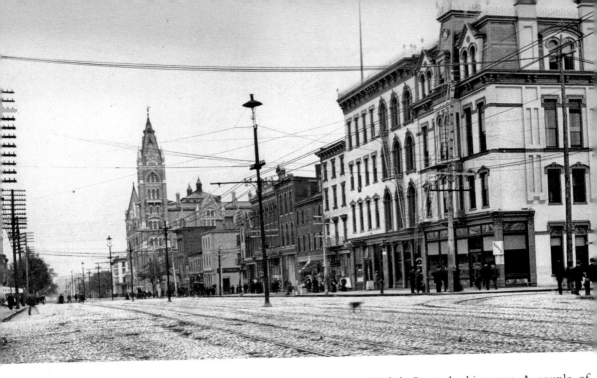

oth of the images show buildings along Broad Street at Eighth Street looking east. A couple of buildings—the Murphy Hotel and the General Assembly building—and a parking lot have replaced a dozen smaller row buildings seen in the historic photograph. Broad Street was filled with commercial buildings that have in the past vanished from this historical street. The Murphy Hotel was built in 1911 and is now known as the state's Eighth Street Office Building. The building is owned by the state and slated for possible demolition. In the distance is the old city hall built in 1894.

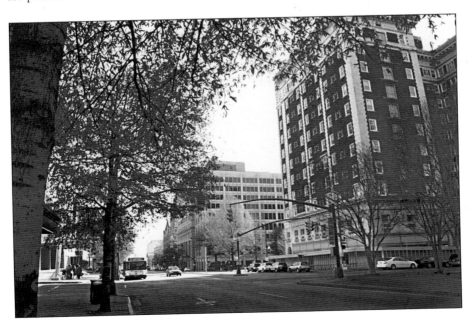

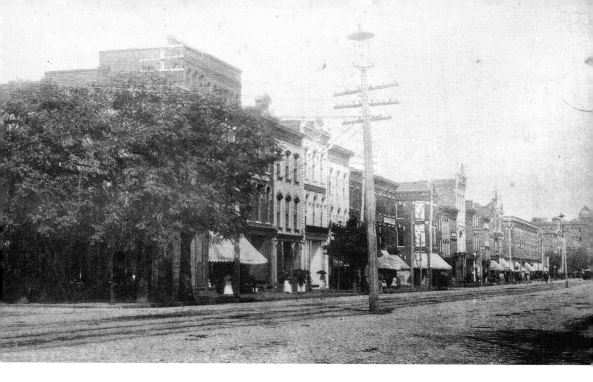

The photographs are views of Broad Street at Fifth Street looking west. In the past, Broad Street was lined with shops. Many Richmonders remember shopping at the department stores Miller and Rhoads and Talhimers. Most of the commerce has disappeared from Broad Street. Recently the department stores have been demolished to make way for a Performing Arts Center. In the distance is the Masonic Temple, constructed in 1888–1893 and designed by Jackson Gott. The floors upstairs contained meeting rooms and a ballroom for the Masons. Pres. Theodore Roosevelt was hosted here. The department store Woodward and Lothrop used to occupy the downstairs of the building. The ballroom can be rented now for social functions.

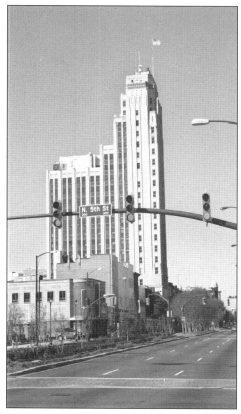

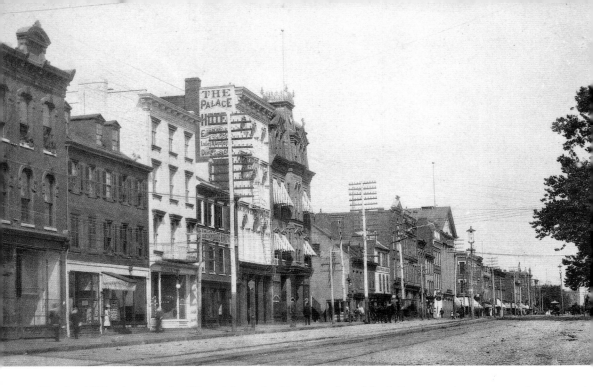

In the 1890s photograph of Broad Street looking west from Ninth Street can be seen several commercial businesses. An art gallery and the European Palace Hotel are some of the businesses that used to be on this block. Now on this site are a parking lot and the historic Murphy Hotel. The hotel was designed by John Kevan Peebles, the same architect that designed additions for the Virginia State Capitol building. Right now the city wants to demolish this building to make more office space. The preservation organizations are fighting for adaptive re-use of the building to maintain the historical structure and renovate the interior.

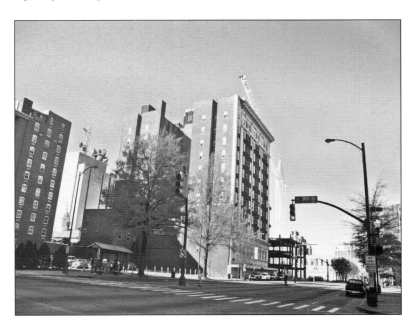

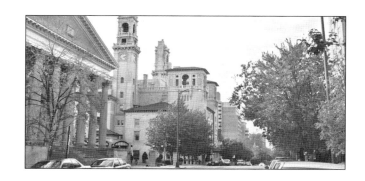

The Jefferson Hotel at West Franklin and Adams Streets can be seen on the left of this streetscape of Grace Street. The building of the hotel was funded by the tobacco merchant Maj. Lewis Ginter, who thought Richmond needed a grand hotel like those found in Europe. The New York architects Carrere and Hasting designed the building in 1890s, and the structure was completed in 1895. The south section of the building was destroyed in a fire in 1901 and rebuilt by the architect J. Kevan Peebles. In the 1930s, it is reported that alligators actually lived in a fountain in the Palm Court lobby. The hotel contains over 200 rooms and is still Richmond's grandest hotel. The latest renovation took place in 1992 with millions spent to improve amenities. Elvis Presley is just one of the many famous people to spend the night in this grand hotel.

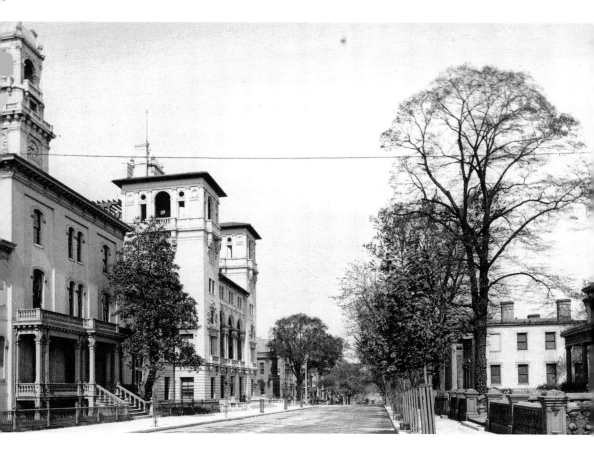

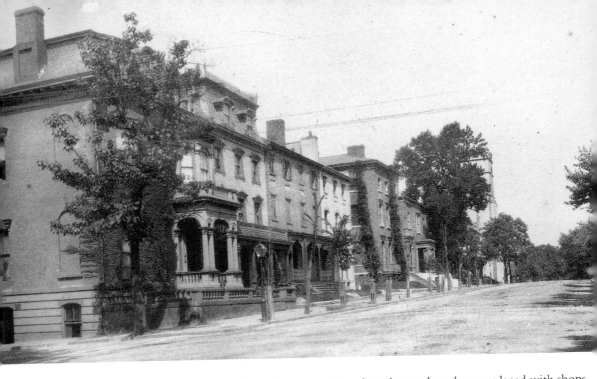

Homes lined Grace Street in the 1890s heading west. Now those homes have been replaced with shops and theaters. The current image shows the back side of the Miller and Rhoads department store. On Grace and Sixth Streets is the historic Lowe's Theater designed by John Eberson. The architect designed the 1920s movie palace with a baroque style. The theater was restored in the 1980s by the Virginia Center for the Performing Arts and is now the home of the Carpenter Center for the Performing Arts.

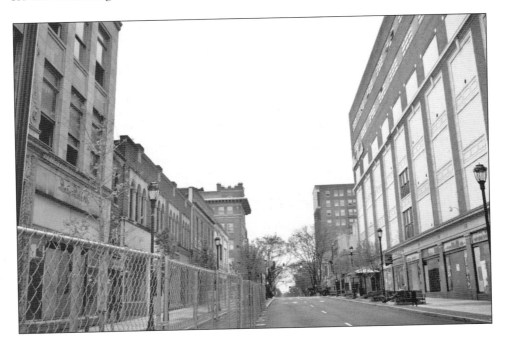

The photographs look east towards historic Shockoe Bottom. At the corner of Main and Tenth Streets was John L. Williams and Son's banking house. The building used to be the U.S. Custom House, designed by Boston architect Ammi B. Young around 1858. In 1861, the Confederacy seized the building and used it for the treasury and office space for Confederate president Jefferson Davis. President Davis was brought to this building when he was indicted with treason. The building has been expanded over the years and is now a federal court building.

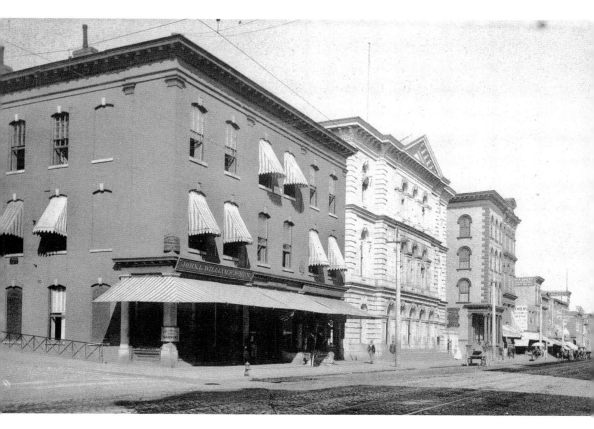

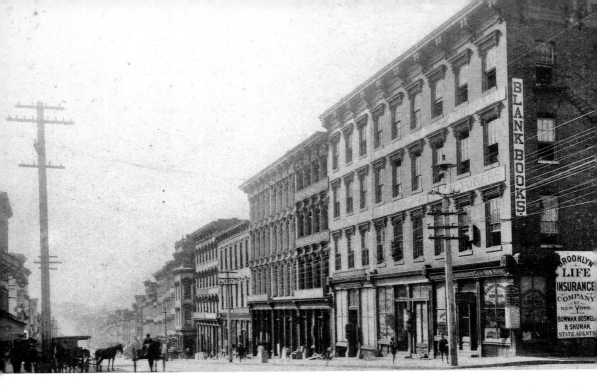

Several of the 1890s buildings in the past photograph can still be seen in the present image. This Ironfront building at 1207–1211 East Main Street was built in 1866 during Richmond's Reconstruction period. Most of Main Street was destroyed in the 1865 evacuation fire. Many of the buildings after the war were made with an iron façade thought to make the building fireproof. The Ironfront building pictured here was a hardware store for the Donnan Brothers. Now the buildings on this street have commercial properties at street level and apartments on the higher levels.

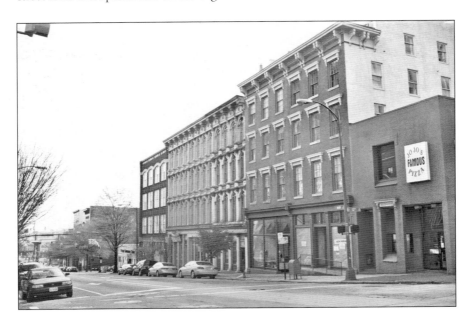

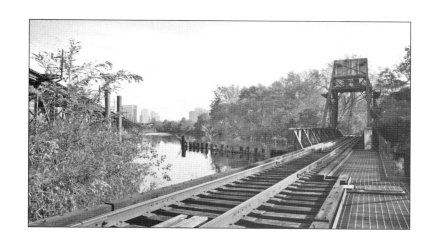

The Kanawha Canal is one of the nation's first commercial canal systems dug between the late 18th and early 19th centuries. The canal formed a water path for trade along parts of the East Coast. The canal system was abandoned in the early 20th century. The railroad tracks can be seen in both photographs. In 1880, the Kanawha Canal closed, and railroad tracks were laid in the canal's path. The rail system was very important as transportation of both commuters and goods. The Chesapeake & Ohio Railway operated 1,431 miles of road and reached west, northwest, and to Mexico. The C&O Railway also operated steamer lines to Europe. Approximately 80 passenger trains arrived and departed Richmond daily in the 1890s with 3,000 passengers being handled daily.

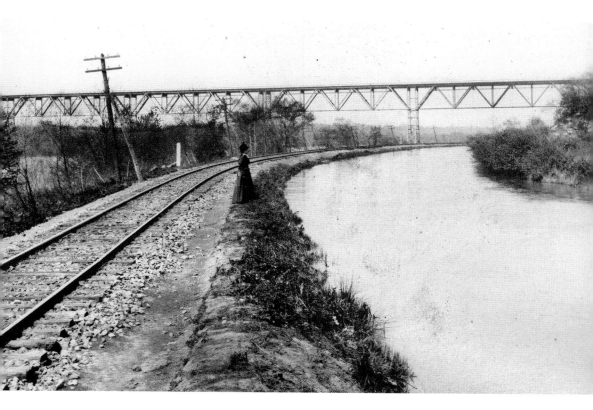

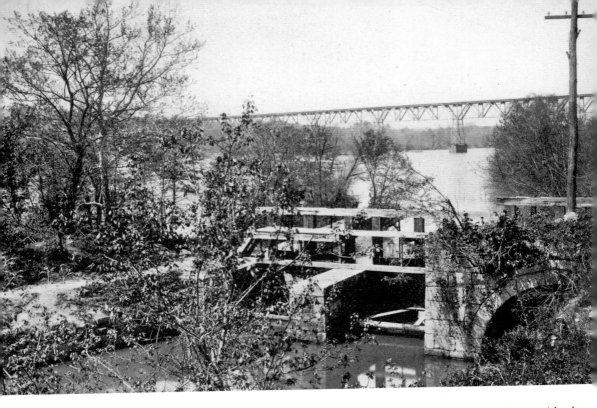

The Canal Lock, completed in 1854, connected the navigable part of the James River with the Richmond city dock. The city dock linked Richmond with ocean trade. Flour, iron, and tobacco were shipped to Atlantic ports. In return, coffee, fertilizer, and dry goods were brought in from other cities. Ships were raised from sea level to the height of the dock. The first locks were wood that decayed; they were restored by the Reynolds Metal Company in 1997–1999. The site is now a city park, which allows the public to walk across the locks for a view of the canal.

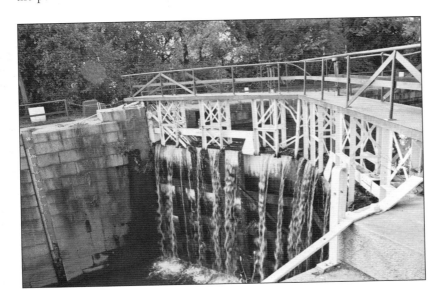

During the Civil War, earthworks also known as trenches were dug all around fort sites to protect soldiers during battles. These earthworks are located near the Confederate Fort Harrison. Union troops captured the fort on September 29, 1864. Fourteen black Union soldiers were awarded the Medal of Honor for their heroics during that attack. Fort Harrison was occupied by the Union for the rest of the war. The earthworks can still be seen on the side of the road around Fort Harrison.

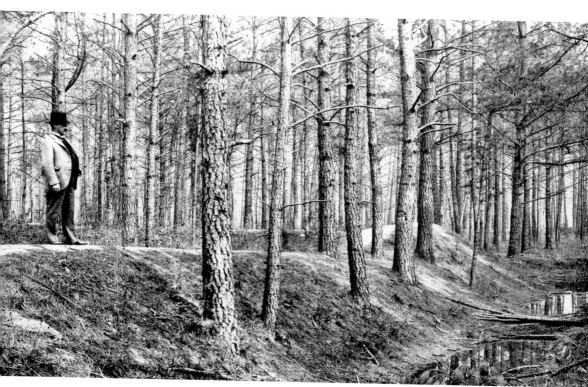

The city of Richmond was established because of its close proximity to the James River. The James River allowed for European trade, East Coast transportation, and the import/export of goods to South America. A revitalization project in Richmond has been developed for the city's riverfront. The Richmond riverfront stretches 1.25 miles from the Tredegar Iron Works to Seventeenth Street. The city has provided a pedestrian walkway, and the path is located near restaurants and shops. The vision is to create an atmosphere like that of Baltimore, Maryland, and Alexandria, Virginia. In the vintage photograph, there is just one factory in the distance in contrast with the recent photograph, where the city is shown with a variety of buildings.

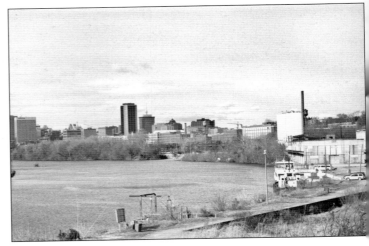

Chapter 5

PUBLIC BUILDINGS AND BUSINESSES

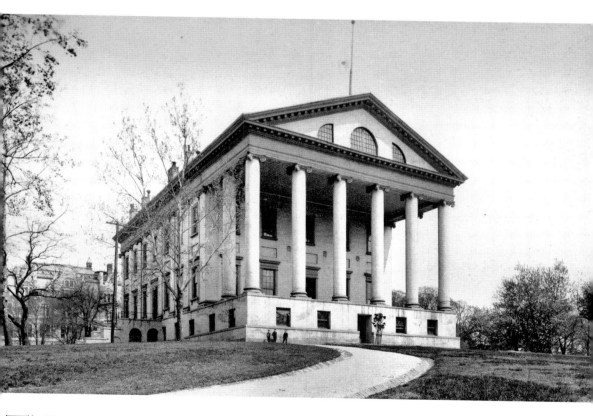

The Virginia State Capitol was designed by Thomas Jefferson around 1785. The design for the Capitol was inspired by the Maison Carree in Nimes, France. The building was used by the Confederate Congress during the Civil War. The building was almost demolished after the third floor collapsed in the 1870s, killing 60 and injuring 250. There have been several additions and restorations to this building through the years. In 1906, the pair of wings was added by architects Peebles and Noland. Currently, the building is undergoing another expansion/restoration for Jamestown's upcoming 400th anniversary in 2007.

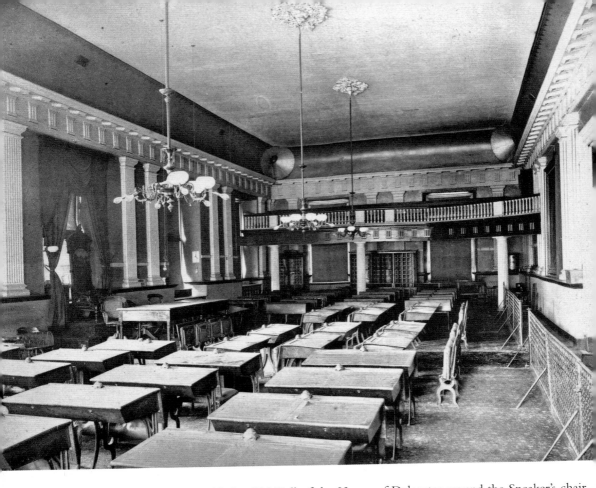

In the 1890s photograph, desks fill the Old Hall of the House of Delegates around the Speaker's chair. This is the largest room in the original structure of the Capitol. The hall is located off of the Rotunda in the north section of the building. From 1788 to 1904, the hall was used by the Virginia House of Delegates. Today this area is undergoing considerable reconstruction to preserve the facility for future generations of visitors. The hall is now a part of the museum section of the Capitol with tours provided daily.

Above the statue of George Washington is a balcony where several rows of portraits hung before the 20th century. The rotunda gallery was a museum where a stove, an original Speaker's chair from the House of Burgesses, and portraits of important Virginians were on display. Today only portraits of Virginia's most recent governors are featured in this area. During the restoration, the portraits are on display at the Library of Virginia. The library exhibit is called "Virginia Collects: Art from Capitol Square" and includes the stature of Henry Clay and several busts from the niches in the rotunda.

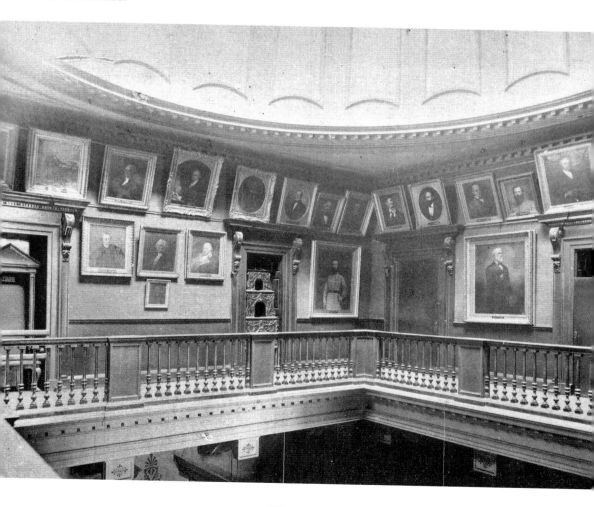

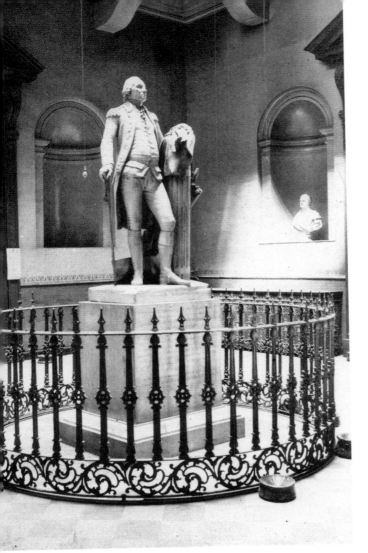

Under the rotunda of the Virginia State Capitol stands a statue of George Washington designed by Jean-Antoine Houdon in 1785. The rotunda's dome is hidden from the outside by a gable roof. The life-sized statue of Washington is made of Italian Carrara marble, the same material the 16th-century Italian sculptor Michelangelo used for his famous sculptures. The statue was shipped to Virginia in 1796. The statue has never left the rotunda since its dedication. For the duration of the restoration, the statue of Washington will be safely housed in a wooden box; note the climate control unit on the side of the box.

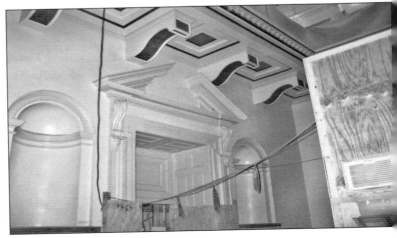

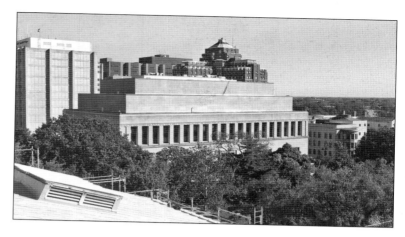

Both images provide east views from the Capitol. The 1890s view shows how the city was filled with factories and warehouses leading up to the canal. In the recent photograph, buildings in the distance are covered by the taller 1930s Supreme Court Building and 1940s West Hospital. The Supreme Court Building was also the State Library, and in the 1970s, the stepped-pyramid on the roof was added. West Hospital is being considered for demolition for a new medical facility. In the far distance is Broad Street heading east to Church Hill.

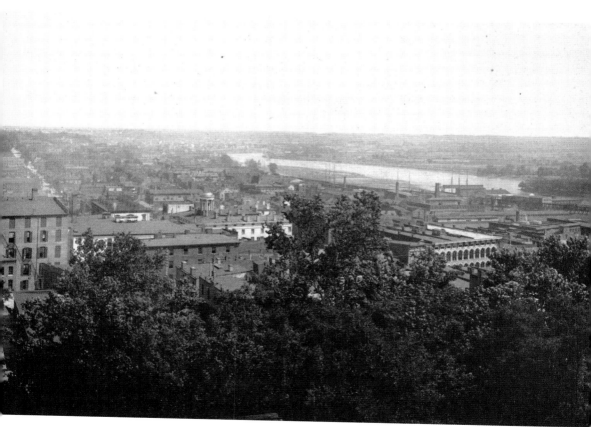

The State Library on Capitol Square was designed by William Poindexter and completed in 1895. Construction for a new building for the library began on Broad Street in 1993. The old building needed improvements that would be too costly to undertake. The structure is now called the Patrick Henry Building and now holds the governor's working office, offices of the cabinet secretaries, offices for the Virginia Department of Planning and Budget, and some offices for the Department of General Services.

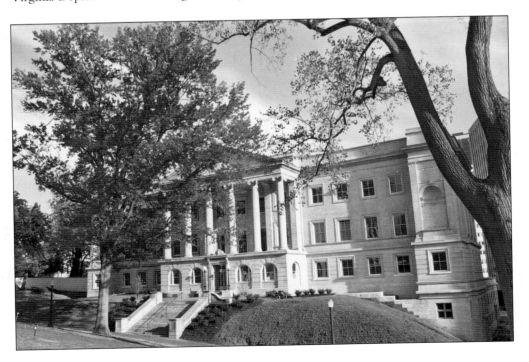

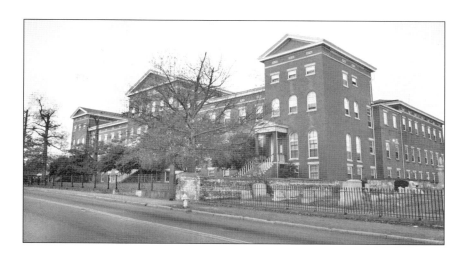

The Almshouse at 210 Hospital Street was built between 1860 and 1861 as a house for the Richmond's white poor. The home was designed by Richmond city engineer Washington Gill. The building then served as a Confederate hospital during the Civil War, and for a short period of time, this structure was home to the Virginia Military Institute. In 1908, the West Building was added to house the poor blacks of the city. Renovated in the 1980s, the building is now a nursing home. Across the street from this building is Richmond's historic Shockoe Cemetery.

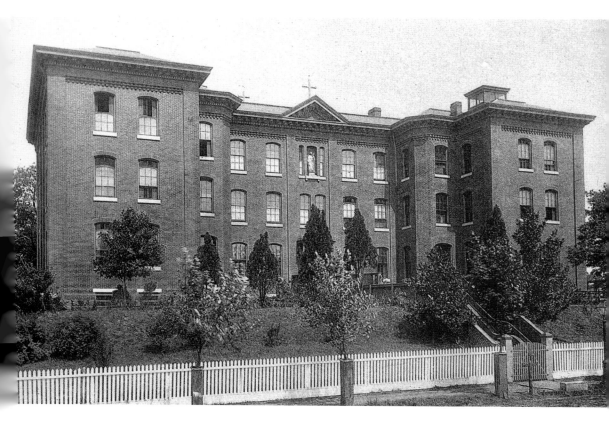

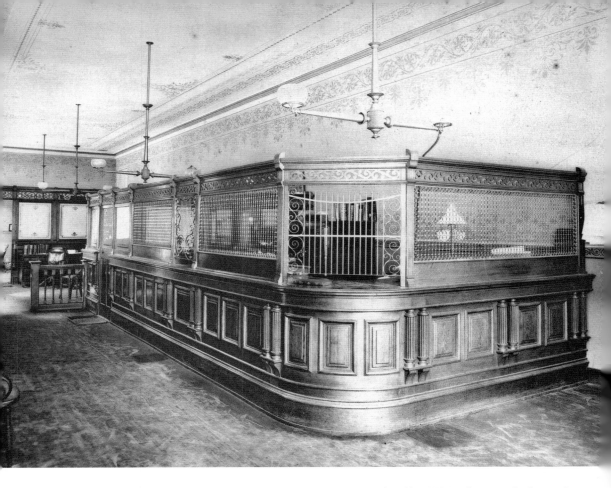

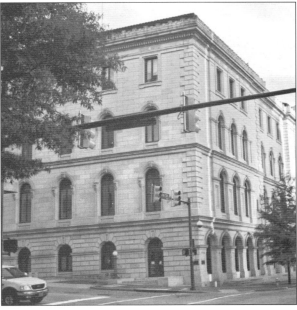

The 1890s photograph shows the interior of John L. Williams and Son's banking house. The building stood at 1000 East Main Street. In 1897, Richmond boasted four national banks, four state banks, four savings banks, and two trust companies. The Lewis F. Powell Courthouse now occupies this corner. The courthouse was originally the U.S. Custom House designed by Ammi Young, a Boston architect. The building was originally completed in 1858 and did occupy the space of the banking house. Jefferson Davis was brought here for his treason indictment, which in 1868 was dismissed.

The construction of the chamber of commerce was begun in 1892 at Ninth and Main Streets. Richmond architect Marion J. Dimmock designed the building, which had six floors and a courtyard with a skylight. The structure was demolished in 1911 and replaced with the First and Merchants National Bank. The bank building was completed in 1913 by New York architect Alfred Charles Bossom and became Richmond's first high-rise. Skyscrapers were possible because of the use of steel frames and the invention of elevators to get pedestrians to the upper floors. The building now holds office space.

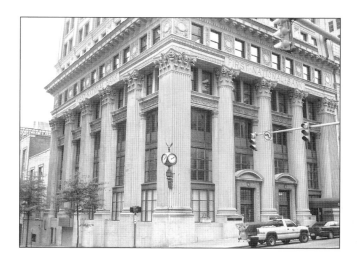

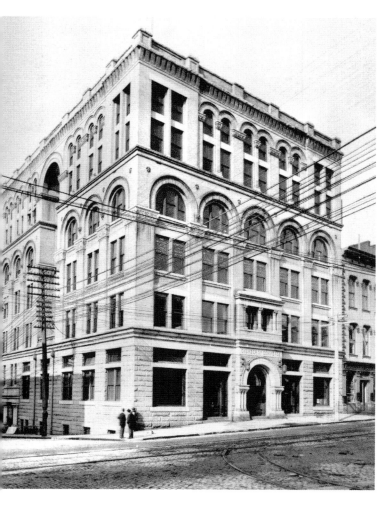

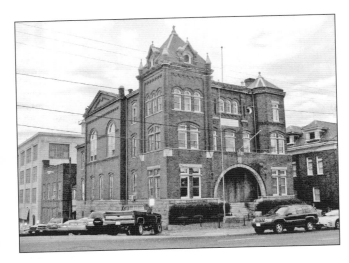

The Henrico County Courthouse still stands on Twenty-second and Main Streets and is now privately owed. On July 2, 1782, near this building 12 citizens constituted the first Richmond city government. The group met the next day to elect the city's first mayor, William Foushee. The courthouse building was designed in 1896 by the German architect Carl Ruehrmund, who immigrated to the United States in 1881. He first worked in Philadelphia and then moved to Richmond to remodel the post office. Ruehrmund started a partnership with Albert Lybrock, who designed the Monroe Monument and Mozart Academy.

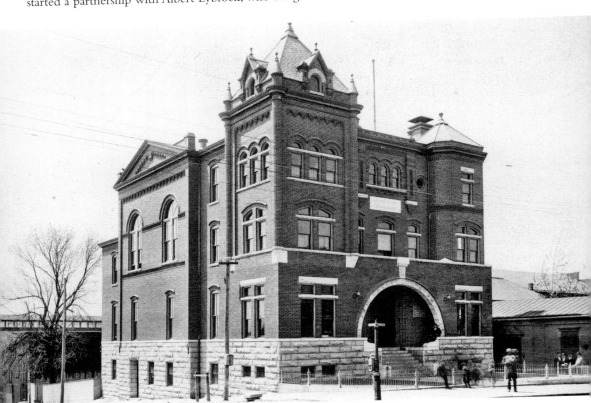

This is Richmond's second city hall. Now that the city has a new city hall, the one pictured here is often referred to as Old City Hall. The first city hall was designed by Robert Mills in 1816 and demolished in 1874. This Gothic building was designed in 1887 by Elijah E. Myers, who is known for designing five state capitols. City engineer Col. Wilfred E. Cutshaw supervised the construction of this building. Made of Richmond granite, the building was completed in 1894 and still stands at Broad and Tenth Streets. The building is now used for commercial office space.

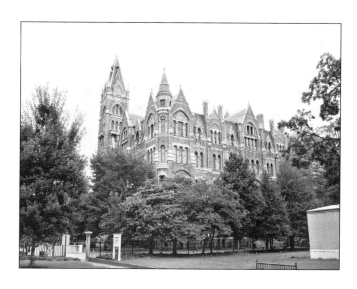

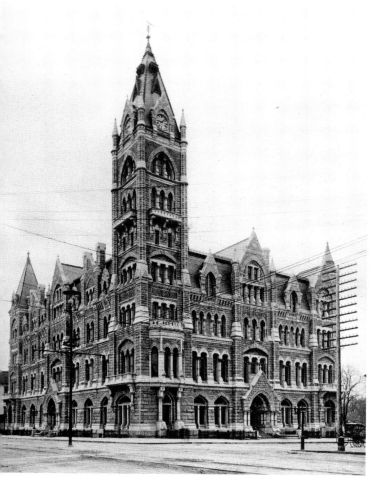

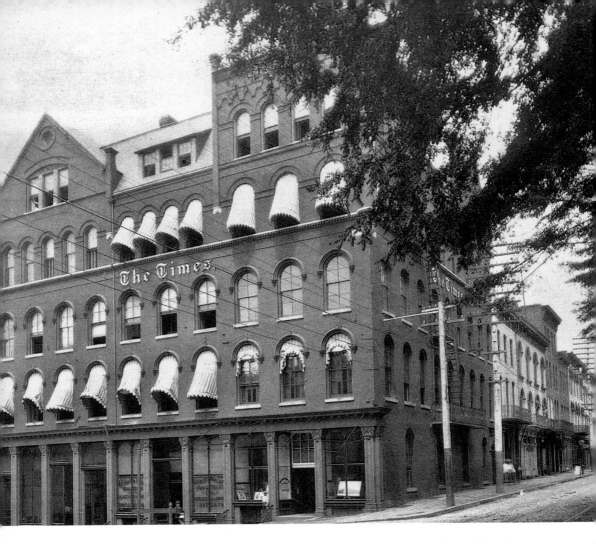

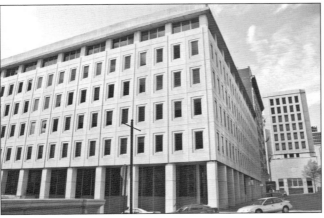

In 1891, the *Richmond Times* was owned by Virginia native and Confederate veteran Joseph Bryan. The *Times* was the only paper in Virginia published every day during the week, including Sundays. The cost for a subscription was $5 for a year of daily issues and $1.50 for a year of Sunday issues. The *Richmond Times* building was located at Tenth and Bank Streets with one side facing Capitol Square Park. This is now the site of the Pocahontas Building, which holds several offices including the Virginia Credit Union.

The photograph shows the interior of the Mozart Academy, which was located at 103–105 North Eighth Street. The Academy was designed in 1886 by the German architect Albert Lybrock. The architect immigrated to the United States in 1849 and died January 17, 1886, the day the Academy opened. Lybrock is best known for his design of the James Monroe memorial in Hollywood Cemetery. Sarah Bernhardt, Maude Adams, and Ethel Barrymore performed on the Academy stage. The building was destroyed by fire in 1927. This is now the site of a Richmond city court.

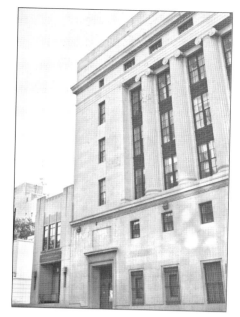

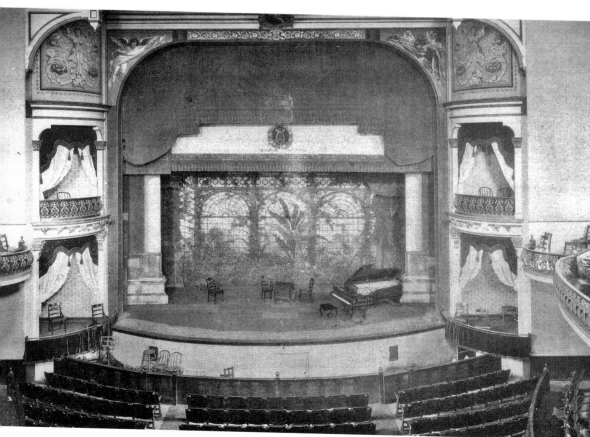

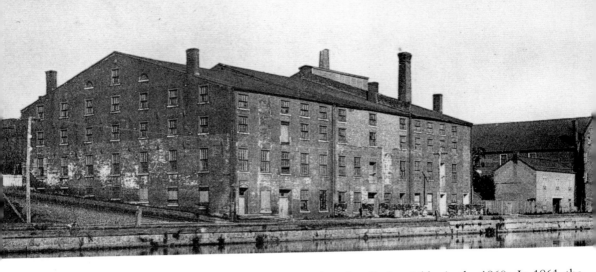

At Twentieth and Cary Streets stood the warehouse leased to Luther Libby in the 1860s. In 1861, the Confederacy seized the warehouse and used it for a prison. Thousands of Confederate officers were held at Libby Prison. In 1888, the building was purchased and rebuilt in Chicago as a museum. In 1893, the structure was a part of the Chicago World's Columbian Exposition. The Libby Prison in Chicago was demolished in 1900. The site in Richmond is part of the flood wall. There is a plaque commemorating the site of the prison.

The production of flour was a major export in the city of Richmond. The Haxall family created a dynasty in the flour milling business. The Haxall Mills were located near Twelfth and Thirteenth Streets near the banks of the James River. The Haxall Mills survived the evacuation fire of April 3, 1865, and was expanded and renovated several times. The mill closed sometime after 1891. This area is now a part of the Canal Walk, a historic area where pedestrians can learn about Richmond's industrial history while enjoying a leisurely stroll and beautiful views.

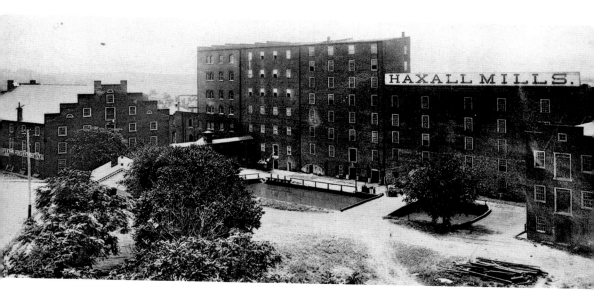

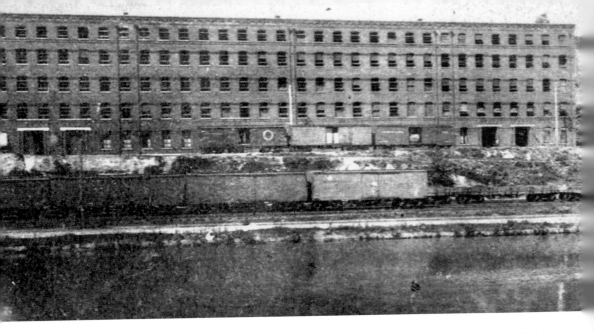

The Kinney Tobacco building still stands at Twenty-fifth and Cary Streets on Richmond's historic Tobacco Row. Cary Street was lined with tobacco factories due to the growing demand for tobacco. Manufactured tobacco would be shipped from Richmond to destinations all over the world. One of the main tobacco merchants was Maj. Lewis Ginter, who made a fortune by manufacturing pre-rolled cigarettes in attractive packaging. In 1889, Kinney Tobacco, Ginter and Allen Tobacco, Kimball and Company; and W. Duke Sons and Company merged to form the American Tobacco Company. The building is now an apartment complex.

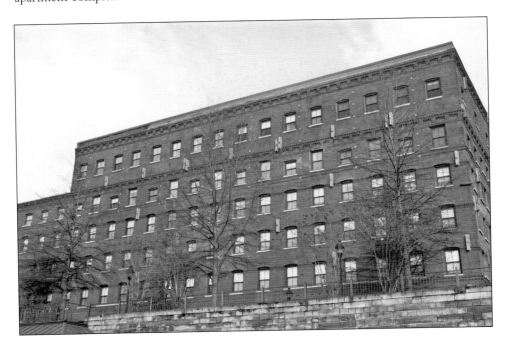

Situated on Richmond's commercial Main Street was Merchants National Bank. In the 1890s, the president of the bank was John Patterson Branch. In 1870, John Branch and his father, Thomas Branch, founded Merchants National Bank. The banking business prospered in the 1880s, and Branch purchased land on what would become Richmond's historic Monument Avenue. Upon John's death, his estate was valued at $2,795,000. Today the 1000 block of Main Street is occupied by the Bank of America building complex. This includes space for the Greater Richmond Transit Company (GRTC) Commuter Center and Four Eyes optical showroom.

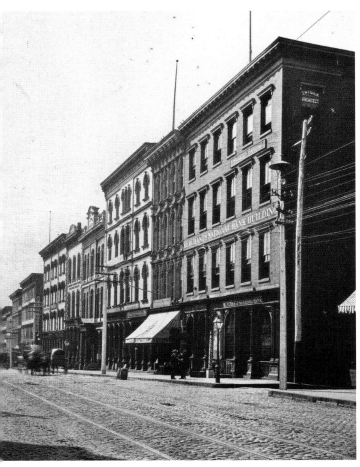

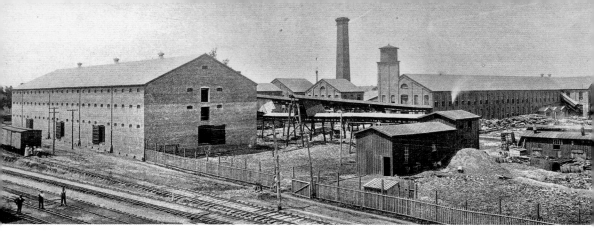

The buildings for the Richmond Cedar Works can still be found off of Orleans Street and Williamsburg Avenue going toward the James River plantations. The buildings area is now the site for the Village of Rocketts Landing, a development team that has created a plan to revitalize Richmond's riverfront with commercial and residential properties. Many of the historic factories are being renovated with commercial space on the lower level and apartments above. The anticipated completion date of Rocketts Landing is 2012.

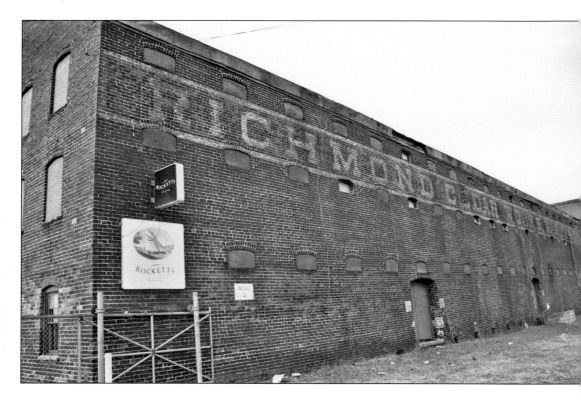

Pictured here is Richmond Locomotive Company at Seventh Street. The president in the 1900s was S. R. Callaway of New York. In the 1890s, the locomotive works would produce approximately 200 trains a year. The use of trains for the transport of goods was increasing rapidly. Railroad track mileage nearly doubled between 1880 and 1890. The plant covered about 12 miles of Richmond's downtown in the 1890s. The area was vacant in the 1930s and later became the site of the Federal Reserve. There have been three buildings for the Federal Reserve in Richmond since 1914. The first was near the federal courts, the second on Capitol Square, and the third building, pictured here, was opened in 1978. The building has a money museum and is open for public tours by reservation.

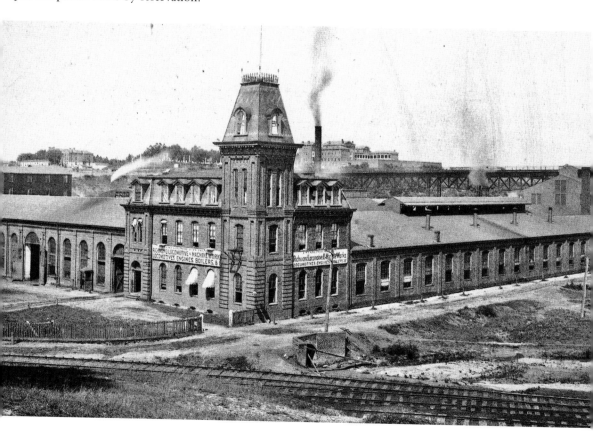

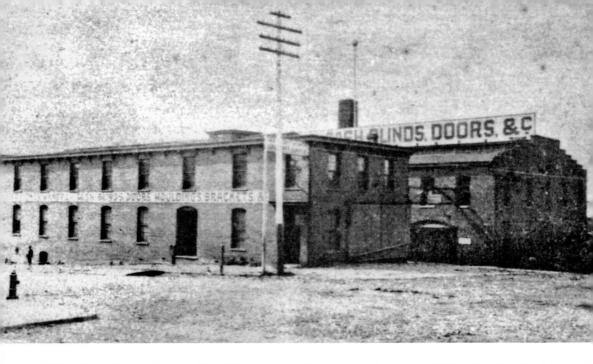

The Sash, Blinds, Doors mill of Whitehurst and Owen was located at 1001–1013 East Byrd Street in the 1890s. Near this site was the Richmond Locomotive Company. The owners of the mill were J. Whitehurst and Harry B. Owen. In 1902, Owen no longer lived in Richmond and the company name included Mayo and Hysore. The area off of Byrd Street is now a part of the Richmond Metropolitan Authority parking deck and the Kanawha Plaza. In the summer, musical concerts are offered in the plaza.

In the 1890s, the address for the Habilston and Brothers store was 905 East Main Street. The brothers, Fredrick and Charles, sold artistic furniture, mirrors, and draperies in this shop for only a few more years. In the 1902 Richmond directory, Fredrick has no occupational listing and Charles is the president of the Richmond Broom Company. At 901 East Main was the railroad ticket office for the Richmond Transfer Company. Now on this site are early-20th-century sky-rise buildings used for professional office space.

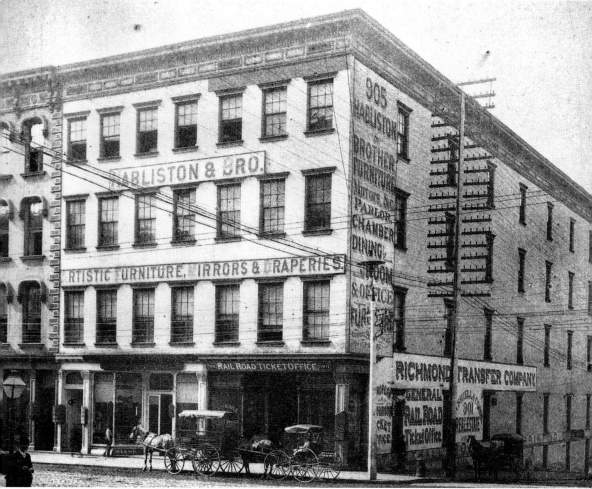

REFERENCES

Art Work of Richmond. Chicago, IL: W. H. Parish Publishing Company, 1897.

Baist, G. William. *Atlas of the City of Richmond, Virginia and Vicinity*. Richmond: William Baist, 1889.

Brownell, Charles E., Calder Loth, William M. S. Rasmussen, and Richard Guy Wilson. *The Making of Virginia Architecture*. Richmond: Virginia Museum of Fine Arts, 1992.

Carneal, Drew St. J. *Richmond's Fan District*. Richmond: Historic Richmond Foundation, 1996.

Case, Keshia A. "Alexander Parris in Richmond: 1810–1812." M.A. thesis, Virginia Commonwealth University, 2004.

Green, Bryan Clark, Calder Loth, and William M. S. Rasmussen. *Lost Virginia: Vanished Architecture of the Old Dominion*. Charlottesville, VA: Howell Press, 2001.

Loth, Calder ed. *The Virginia Landmarks Register*. Charlottesville: University Press of Virginia, 1999.

McGraw, Mary Tyler. *At the Falls: Richmond, Virginia & Its People*. Chapel Hill, NC: North Carolina Press, 1994.

Moore, Samuel Jr. *Moore's Complete Civil War Guide to Richmond*. Richmond: Samuel Moore Jr., 1973.

Richardson, Sheldon. "Architect of the City: Wilfred Emory Cutshaw (1838–1907) and Municipal Architecture in Richmond." M.A. thesis, Virginia Commonwealth University, 1997.

Richmond City Directory. 1890–1902.

Richmond, Virginia Illustrated. Indianapolis, IN: Wm. B Burford, 1891.

Ryan, David D. and Wayland W. Rennie. *Lewis Ginter's Richmond*. Richmond: Whittet and Shepperson, 1991.

Sanford, James K. *Richmond: Her Triumphs, Tragedies & Growth*. Richmond: Metropolitan Richmond Chamber of Commerce, 1975.

Scott, Mary Wingfield. *Houses of Old Richmond*. New York: Bonanza Books, 1941.

Winthrop, Robert P. *Architecture in Down Town Richmond*. Junior Board of Historic Richmond Foundation Richmond, 1982.